W9-CEO-752

Treasures of the
Musée d'Orsay

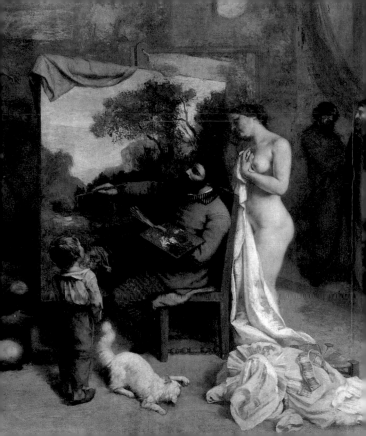

Treasures of the
Musée d'Orsay

Introduction by Françoise Cachin
Chapter introductions by Xavier Carrère

A TINY FOLIO™
Abbeville Press Publishers
New York London Paris

Front cover: Detail of Edouard Manet, *Olympia,* 1863. See page 87.
Back cover: Vincent van Gogh, *The Artist's Bedroom in Arles,* 1889. See page 167.
Spine: Pierre-Auguste Renoir, *Madame Renoir,* 1916. See page 250.
Frontispiece: Detail of Gustave Courbet, *The Painter's Studio: Allegory of Seven Years of My Artistic and Moral Life,* 1854–55. See page 49.
Page 6: Interior of the Musée d'Orsay.
Page 11: Exterior of the Musée d'Orsay.
Page 24: Detail of Thomas Couture, *The Romans of the Decadence,* 1847. See page 30.
Page 38: Detail of Camille Corot, *The Artist's Studio, Young Woman with a Mandolin,* c. 1865. See page 45.
Page 66: Detail of Ernest Meissonier, *Campaign in France, 1814,* 1864. See page 69.
Page 82: Detail of Edouard Manet, *Luncheon on the Grass,* 1863. See page 86.
Page 150: Detail of Vincent van Gogh, *The Woman of Arles,* 1888. See page 166.
Page 218: Detail of Edgar Degas, *Little Dancer Fourteen Years Old,* 1881. See page 245.
Page 254: Detail of William Morris, with William De Morgan, *Panel,* c. 1876–77. See page 266.
Page 284: Detail of Mary Cassatt, *Mother and Child Against a Green Background,* or *Maternity,* 1897. See page 296.
Page 298: Detail of Honoré Daumier, *The Print Collectors,* n.d. See page 301.
Page 320: Detail of André Granet, *Project for the Lighting of the Eiffel Tower for the Exposition Universelle of 1937,* n.d. See page 334.
Page 338: Detail of Nadar, *Baudelaire Seated on a Louis XIII Chair,* 1855. See page 347.

CONTENTS

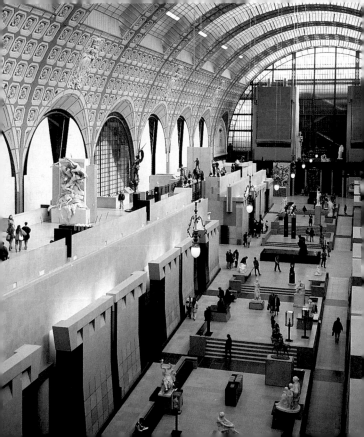

INTRODUCTION

Françoise Cachin

The end of the twentieth century has seen a growing interest in the intellectual and artistic creation of the previous century in Europe, before the fragmentation provoked by World War I. This current curiosity, possibly tinged with a bit of nostalgia, is embodied in the crowds of French and foreign visitors to the Musée d'Orsay: some thirty million to date, if we include those who have come to view the temporary exhibitions organized by the museum at the nearby Grand Palais. The connection between these two great structures, which were both conceived for the Exposition Universelle of 1900, is thus still alive and well one century later: the Grand Palais was and still is devoted to exhibitions; the Orsay train station and hotel, formerly intended to receive and house visitors arriving from southwestern Europe to the heart of Paris, has become the Musée d'Orsay.

"The train station is magnificent and looks like a palace of fine arts, and since the Palace of Fine Arts looks like a train station, I suggested to Laloux [the Orsay

architect] that he switch them if there was still time!" wrote the academic painter Edouard Detaille in 1900, before the inauguration of the two buildings. His mission for the train station, at least, was accomplished as of December 1986.

Let's back up a bit to the circumstances that led to the preposterous concept of transforming a train station into a museum. This idea resulted from several changes that had occurred in the 1970s. In 1977 the transfer of the twentieth-century art collections to the Centre d'Art et de Culture Georges Pompidou (popularly known as the Beaubourg) left an entire segment of art, from Impressionism to Cubism, at the Palais de Tokyo (former site of the Musée National d'Art Moderne). The lack of space at the Jeu de Paume, the Impressionist museum, meant that masterpieces were being kept in storage, as was an entire group of paintings and sculptures at the Musée du Louvre that did not fit into any chronological or aesthetic category at either the Louvre or the Beaubourg. Meanwhile, there was a critical reevaluation taking place of nineteenth-century art that did not fit into the somewhat sectarian history of the avant-gardes; this complemented the desire to show the work of the period as a whole—its photography, architecture, furnishings, and objets d'art as well as its painting and sculpture. All of these forces made

the creation of a new museum an urgent matter—a museum that would form a bridge between the Louvre and the Beaubourg.

Meanwhile, in the heart of Paris, a vacant building was in danger of being destroyed to make way for a hotel: the Orsay train station and hotel, opposite the Louvre and the Tuileries gardens. The building, which had been considered ugly only a few decades earlier—so distinctly was its exterior marked by the eclectic style of the late nineteenth century, even though inside it was a beautiful example of modern architecture in glass and steel—was reconsidered and supported by a forceful press campaign. At the time, Parisians were still reeling from the shock of the recent destruction of Les Halles, the food market that was a masterpiece of steel architecture from the 1850s. The idea of saving the train station dovetailed with the search by the museums and the Ministry of Culture for a site that would provide a dignified setting for Impressionist and Post-Impressionist painting. The container, in short, found its content. The decision dates from 1973; museographic programming began in 1978.

The adaptation of Victor Laloux's 1900 building, classified a historical monument, was entrusted to a trio of young architects—Renaud Bardon, Pierre Colboc, and Jean-Paul Philippon—and then, along with them, to

9

Gae Aulenti for the fine tuning and overall appearance. The museum's team of curators in all disciplines—painting, sculpture, decorative arts, architecture, photography, and so on—led by Michel Laclotte (who, since the opening of the Orsay, has successfully overseen the completion of the Louvre's spectacular renovation and extension), began thinking together about appropriate uses for this train station. For all of us, deciding what should be chosen or eliminated, what the priorities should be and how the spaces should be organized was a difficult, passionate, often contentious process. What a challenge! On the very spot where trains came and went, at the site of so much commotion, of so many timetables and fleeting instants, were to be presented museum objects—which by their very nature aspire to eternity. In addition, permanent exhibition rooms had to be created without destroying the essence of an architectural structure that was itself a museum piece. Some of its main advantages were the immense glass vault overhead and the glass bays overlooking the Seine, diffusing northern light and, from the top floor, affording a marvelous view of Paris and its river.

Let's put aside the building for a moment and go inside the museum, which has been open to the public since December 1986. The period represented runs from

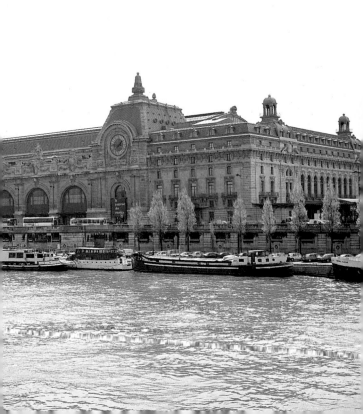

1848 to approximately 1905 for painting, and until 1914 for the rest. Why this time differential? Because pictorial developments generally preceded those of the other arts, displaying paintings made up to the start of World War I would have meant introducing to the Musée d'Orsay Fauvism, Cubism, and the beginnings of abstract art—basically a large part of the Beaubourg's domain and currently considered as belonging more to the beginning of the twentieth century than to the end of the nineteenth. This may, in fact, be open to debate. In any case, clear administrative boundaries had to be determined: thus, artists born between 1820 and 1870 are presented at the Musée d'Orsay; those born before that are in the Louvre, after that, at the Beaubourg. There are a few exceptions: the entire body of work by Edouard Vuillard, who was active until the 1940s, is at the Orsay, while the entire body of work by Henri Matisse, except for the one Neo-Impressionist painting reproduced here, is exhibited at the Beaubourg, even though he was born in 1869. As for Pierre Bonnard, his work is divided between the two institutions. Similarly, we did not wish to cut artists off from their immediate sources: thus, the tour of the museum begins with a few late works by Camille Corot, Eugène Delacroix, Jean-Auguste-Dominique Ingres, François Rude, and Honoré Daumier, all of whom

belong to the generation presented on the other side of the Seine, at the Louvre.

The dates 1848 and 1905, which in principle mark the beginning and end of the artistic creation shown here, may seem arbitrary boundaries, and a half-century of creation may seem a minor affair. But what a half-century it was! A time of such prodigious wealth and variety that the museum's eighteen thousand square meters of exhibition space barely suffice to contain it.

This mid-century corresponds, historically and culturally, to a moment of transition: it saw the appearance and recognition of Realism in the work of Gustave Courbet, Jean-François Millet, and the Barbizon landscape artists, as well as the first Universal Expositions (London, 1851; and Paris, 1855 and 1867). These world fairs disseminated European art and were a forum first for confrontation and eventually for association between art and industry, helping stimulate developments such as still photography and cinema. During this time, high-quality industrial art also emerged, conceived at first in England by groups of artist-artisans who were soon to be the creators of the Arts and Crafts movement. At the same time, new uses of steel were coming about that would soon transform architecture.

Such new tendencies faced increasing resistance

from the eclectic, academic tradition, which would soon be nicknamed "*art pompier.*" One of the particularities of the Musée d'Orsay is that it conveys these tensions and shows the variety of all these different modes of creation. Thus, the ground floor (the first part of the visit, ranging from 1848 to the 1870s, which more or less corresponds to the Second Empire in France) is divided in two by an alley of sculptures, ending in a sort of square dominated by the greatest French sculptor of the era, Jean-Baptiste Carpeaux. A series of models also evokes Baron Haussmann's new Paris and Charles Garnier's Opéra. On the right-hand side of this aisle is displayed work in the classical or academic current, featuring history painting, large decorative panels, and portraits, from Ingres and Delacroix to Pierre Puvis de Chavannes and the young Edgar Degas.

On the left, in opposition to Ingrism and Romanticism, are the social scenes and caricatures sculpted by Daumier, the Realism of the Barbizon landscape painters, and particularly the work of Courbet, whose large canvases, *Burial at Ornans* and *The Studio,* mark the beginning of a "new painting" even more than the famous Salon des Refusés of 1863. The hero of modernity in the 1860s, Edouard Manet, is represented opposite his friend Degas, who evolved out of the Ingres tradition but was also con-

nected with the new generation of Claude Monet, Pierre-Auguste Renoir, Alfred Sisley, and Paul Cézanne —all future members of the Impressionist group. Work by these artists constitutes some of the museum's greatest highlights. The selection of their paintings in this small volume is necessarily restricted: we mustn't forget that of the some twenty-five hundred paintings that belong to the Musée d'Orsay (of which one thousand are on display), only 180 are reproduced here.

The second part of the painting tour takes the visitor behind the towers at the end of the aisle and onto the escalator to the upper gallery, where the glass roof diffuses the same fluctuating daylight that the Impressionists had made their subject. These artists are represented here in all their glory. After the masterpieces of the 1870s, each painter —Manet, Degas, Renoir, Monet, Cézanne —receives a comprehensive display.

Next comes another of the museum's most popular areas: beautiful series by Vincent van Gogh, Paul Gauguin, and the Pont-Aven school; Georges Seurat and the Neo-Impressionists; Odilon Redon and Henri de Toulouse-Lautrec. After that section the visitor must go down to the middle floor to reach the exhibition spaces that open onto terraces filled with statues, ending in an esplanade devoted to the second great sculptor presented

at the Musée d'Orsay: Auguste Rodin, with his *Gates of Hell* and *Balzac.*

To the left of the esplanade is a group of paintings that embodies the official and fashionable taste of the Third Republic, which preferred Léon Bonnat and William Bouguereau to Manet, and Ernest Meissonnier and Giovanni Boldini to Degas. Here we find famous portraits—from Albert Edelfelt's *Pasteur* to Jacques-Emile Blanche's *Proust,* as well as images that have filled the history books of several generations of young French students, such as Edouard Detaille's *Dream* and Jean-Paul Laurens's *Excommunication of Robert the Pious in 998.* Not far from here are works by foreign artists, often wisely acquired by the State at the time they were made. These include paintings by Winslow Homer, the Italian Pelizza di Volpedo, and the Russian Nikolai Nikolaievitch Gay. This section has been strengthened by additions made since the opening of the museum, enabling us to present artists such as Edward Burne-Jones (English), George Hendrik Breitner (Dutch), Ferdinand Hodler (Swiss), Gustav Klimt (Austrian), Edvard Munch (Norwegian), and Valentine Serov (Russian).

Finally, after the rooms devoted to decoration and to French and international Art Nouveau, in which decorative works by Redon and Bonnard are exhibited, the

painting tour ends with works from the turn and early part of the twentieth century, including the Nabis—Maurice Denis, Félix Vallotton, Vuillard, and Bonnard—whom we observe here in their breathtaking maturity. It is Bonnard whose work fills the final room of the circuit, recently enriched by gifts.

While on this topic, let us not forget that the Musée d'Orsay would not exist without the donations and bequests that have been made since the end of the last century and that constitute the majority of the paintings on view here today. We acknowledge these bequests in a special index at the back of this book. Nonetheless, let us briefly retrace these successive acts of generosity. First, that by the painter Gustave Caillebotte, whose bequest of 1896 put a great number of works by his Impressionist friends into the museums; by the Etienne Moreau-Nélatons, collectors who gave Manet's *Luncheon on the Grass* and an excellent selection of Impressionist paintings (1906); by Isaac de Camondo, who, in particular, brought Cézanne into the Louvre and gave Manet's *Balcony* as well as a superb series of works by Degas (1911). Let us also recall the bequests of Chauchard (1909), who gave the state Millet's famous *Angelus* and an exceptional collection of landscape works from the Barbizon School. We should mention particularly the postwar donations by

Dr. Paul Gachet and by his son (seven Cézannes and as many van Goghs) (1949–54), by Eduardo Mollard (1961) and by Max and Rosy Kaganovitch (1973), not to mention Auguste Pellerin's bequest of several works by Cézanne, followed by his family's donation of that artist's *Woman with a Coffee Pot* (1956). Masterpieces have also been left to us by Jacques Doucet (1929) and John Quinn (1927): Henri Rousseau's *Snake Charmer* and Seurat's *Circus,* respectively.

The artists' descendants, too, have allowed works by Frédéric Bazille, Courbet, Degas, Emile Gallé, Monet, Camille Pissarro, Redon, Renoir, Paul Sérusier, Paul Signac, Toulouse-Lautrec, and others to be displayed or better represented. The same generosity has been evident, in the area of portraiture, among the models and their families: this is the source, for example, of Manet's *Zola,* of Franz-Xaver Winterhalter's *Madame Barbe de Rimsky-Korsakov,* of Jules-Elie Delaunay's *Madame Georges Bizet,* of van Gogh's *Dr. Paul Gachet,* of Serov's *Mme. Lvov,* of Louis Welden Hawkins's *Séverine,* and of Bonnard's *Portrait of the Bernheim Brothers*—to cite only those that are reproduced here.

Ever since the principle of *dation*—using works of art for the payment of inheritance taxes—was instituted in France in 1968, numerous masterpieces have thus been

acquired: works by Manet (*The Escape of Rochefort*), Monet (*Luncheon on the Grass* and *Rue Montorgueil, Paris: Festival of June 30, 1878*), Renoir (*Dance in the City*), Bonnard (*The Seasons, The Loge, The Bourgeois Afternoon*), Redon (*Decorative Panels*), and Matisse (*Luxe, calme et volupté*).

We should perhaps note where all the works now exhibited at the Musée d'Orsay were originally housed. To simplify matters: whatever is prior to Impressionism had been at the Louvre, either exhibited (Courbet, for example) or in storage (many academic works). Works by Manet, the Impressionists, and the immediate post-Impressionists (van Gogh, Gauguin, Seurat) had been exhibited at the Jeu de Paume. Painting from after this period—the Nabis, Symbolists, foreign schools, and so on—had been on display or in storage at the Musée National d'Art Moderne before being transferred to the Beaubourg. Just about everything else now on view at the Musée d'Orsay was not being displayed anywhere. Many of the sculptures were in storage or otherwise inaccessible at the Louvre, except those by Carpeaux and Rodin (the Rodin museum has generously entrusted us with certain of its pieces). As with painting, we have endeavored to show the variety of sculpture from the Second Empire to the end of the century: from Auguste Préault's and Jean-Paul Aubé's Romanticism, to Daumier's and then

Jules Dalou's Realism and to the various forms of the classicist revival, from Albert-Ernest Carrier-Belleuse in mid-century to Aristide Maillol and Emile-Antoine Bourdelle at the turn of this century. We go from the eclectic style of classical practitioners such as Charles Cordier and Louis-Ernest Barrias—who played with materials by mixing marble, semiprecious stones, and bronze—to the technical innovations or return to primitivism by painter-sculptors such as Degas and Gauguin.

Since the museum's mandate is to present a multidisciplinary view of this half-century, we have had to attempt to fill in entire areas of creation that had previously been absent from the national collections. Indeed, aside from a few loans from the Musée des Arts Décoratifs, everything now on display at the Musée d'Orsay in the area of furnishings, objets d'art, architecture, and photography has been acquired over the last fifteen years.

The furniture and objets d'art are divided into two main sections. On the ground floor, to the right of the painting circuit, are the rooms devoted to the Second Empire—its wallpapers, the wealth of its gold and cabinet work, the technical refinement of its everyday objects, and several masterpieces of the eclectic neo-Greek and neo-Gothic styles. With few exceptions, we have avoided mixing disciplines or combining paintings, sculptures,

and objects from the same period in one room; there is no "period room" at the Musée d'Orsay, no reconstructed atmosphere. On first glance when entering the museum, the sight of all the sculptures in perspective under the great glass vault may evoke not a specific interior but the style of the Salon exhibitions at the nineteenth-century Expositions Universelles. Painting, here as in the Salons, unfolds in separate galleries, but the whole does not seek to imitate a plush, hothouse effect; on the contrary, the space is defined by the strong contemporary architecture of Gae Aulenti, who emphasized the transparent, metallic structure of Laloux's train station.

The second section of furniture and objets d'art, which is devoted to the international modernist decorative arts of the end of the century—called Art Nouveau, Jugendstil, or modern style—is situated on the second floor and in the upper pavilion. Here we find the pioneers of English design beginning in the 1860s–70s, followed by creators as inventive as Hector Guimard, Emile Gallé, and René-Jules Lalique (France); Henry Van de Velde (Belgium); Charles Rennie Mackintosh (Scotland); Josef Hoffmann and Koloman Moser (Austria); Carlo Bugatti (Italy); and Frank Lloyd Wright (United States).

Many of these creators were architects, a domain that is also represented in the museum by models and

drawings, plans, re-creations, and other projects, a selection of which gives one a sense of the period's variety, from the eclecticism of the Second Empire and the visionary or traditionalist Beaux-Arts style to industrial architecture and Art Nouveau.

To protect them from the damaging effects of light, architectural drawings are shown only in rotation, as are all the other drawings, to which several rooms are devoted. To the Orsay's wonderful collection of nineteenth-century drawings and watercolors, stored at the Cabinet des Arts Graphiques in the Musée du Louvre, has recently been added a series of gifts or acquisitions of works by Charles Baudelaire, Degas, Gauguin, and Seurat, several of which have been selected for inclusion here. While these works on paper cannot be permanently exhibited, the same is not true of the famous pastels by Millet, Manet, and Redon reproduced here, which are kept on display under very faint lighting.

The fragility of photographic paper means that our collection, which is extremely rich, is displayed only for short periods. One should not be surprised, therefore, to find works in this book that might not be seen in the course of one's visit in person. The photographic collection has been established over the last fifteen years with an eye to diversity and internationalism, as evidenced

here by a choice that ranges from early specimens of photography—daguerreotypes or negatives on paper from the years 1840–50 by William Henry Fox Talbot, Charles Nègre, Gustave Le Gray, Nadar, and Lewis Carroll—to the most modern examples by Eugène Atget and Edward Steichen.

In conclusion, I would like to express the wish that this small but dense "tiny Orsay" will help the reader preserve vivid memories of the quality and the variety of works seen at this museum. May it especially instill a desire to return again and again in search of new discoveries.

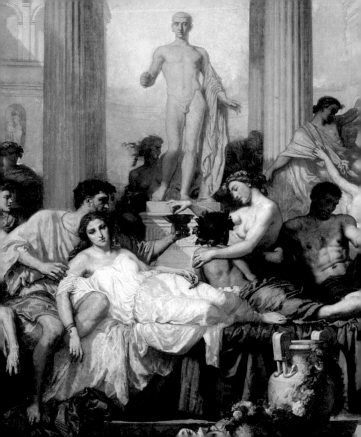

CLASSICISM

"Classicism" defines any art that is founded on admiration of antiquity. The nineteenth century came to be known as the "history century," with its artists capable of admiring and seeking inspiration from all time periods, but it began by declaring itself heir to late eighteenth-century Neoclassicism and the quest for a timeless ideal.

The lofty figure of Jean-Auguste-Dominique Ingres dominates this current. A product of Jacques-Louis David's studio, he later became director of the French Academy in Rome, and a large part of his life was spent in voluntary exile. Ingres's art, far from being solely academic, played a role in the development of artistic modernity, as evidenced by the "Ingrisms" of Edgar Degas, Pierre-Auguste Renoir, and Pablo Picasso, and by Pop Art's many tributes to him. The anatomical distortions that Ingres brought to his figures have often been noted, and their strangeness or archaism have prompted remarks such as Théodore Silvestre's comment that Ingres was a "Chinese painter lost in the mid nineteenth century among the Athenian ruins." Though a believer in the traditional hierarchy of painting types, the pinnacle of which was "history" painting (the narrative portrayal of a

noble subject), Ingres is most celebrated for his portraits and nudes: *Venus at Paphos* (page 27) shows how the painter was able to create a paradoxical eroticism from an incomplete portrait transformed into a nude.

Ingres's formal research did not lend itself to the formation of a school. His collaborators themselves (Amaury-Duval, Hippolyte Flandrin) seem to have been disciples more than students. Théodore Chassériau moved harmoniously from Ingres's teachings into Eugène Delacroix's orbit. Other artists made other transitions: Thomas Couture, whose *Romans of the Decadence* (page 30) was intended as a compromise between Classicism and Romanticism, initiated the eclecticism that his student Edouard Manet was able to expand upon; Pierre Puvis de Chavannes, the father of Symbolism, invented a decorative painting in the full sense of the word, a concept that others, including the Nabis, would later adopt.

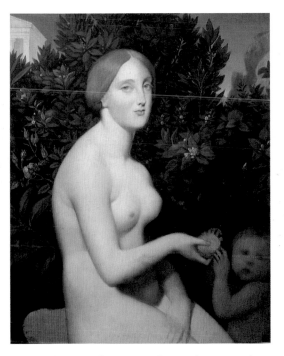

JEAN-AUGUSTE-DOMINIQUE INGRES (1780–1867).
Venus at Paphos, 1852–53. Oil on canvas, 36 x 27⅝ in.
(91 x 70 cm).

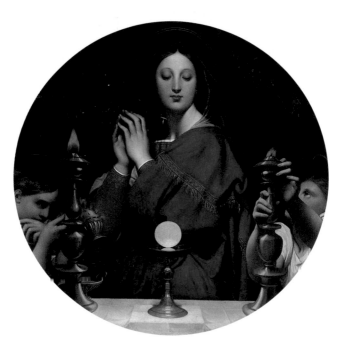

JEAN-AUGUSTE-DOMINIQUE INGRES (1780–1867).
The Virgin with the Host, 1854. Oil on canvas,
diameter: 44 in. (113 cm).

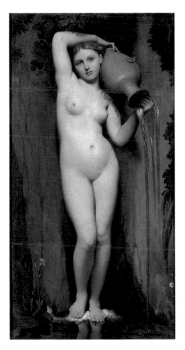

JEAN-AUGUSTE-DOMINIQUE INGRES (1780–1867).
The Spring, 1856. Oil on canvas, 64½ x 31½ in.
(163 x 80 cm).

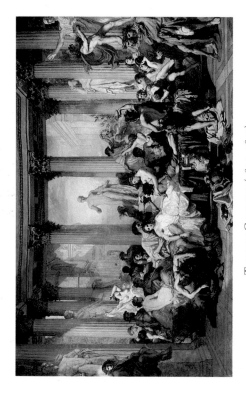

THOMAS COUTURE (1815–1879).
The Romans of the Decadence, 1847. Oil on canvas,
15½ ft. x 25 ft. 3⅝ in. (4.72 x 7.72 m).

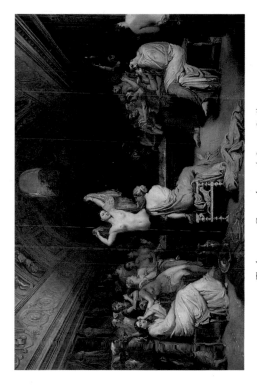

THÉCDORE CHASSÉRIAU (1819–1856).
"The Tepidarium," 1853. Oil on canvas, 67⅜ x 101⅝ in.
(171 x 258 cm).

AMAURY-DUVAL (1808–1885).
Madame de Loynes, 1862. Oil on canvas,
39⅜ x 32⅝ in. (100 x 83 cm).

JULES-ELIE DELAUNAY (1828–1891).
Madame Georges Bizet, 1878. Oil on canvas,
40⅞ x 29½ in. (104 x 75 cm).

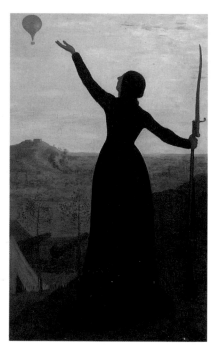

PIERRE PUVIS DE CHAVANNES (1824–1898).
The Balloon, 1870. Oil on canvas, 53⅝ x 33⅞ in.
(136 x 86 cm).

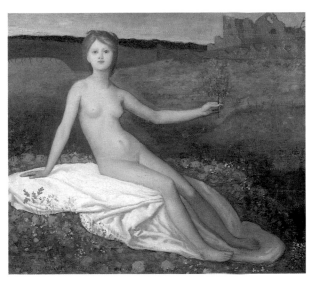

PIERRE PUVIS DE CHAVANNES (1824–1898).
Hope, c. 1872. Oil on canvas, 27⅝ x 32⅜ in.
(70 x 82 cm).

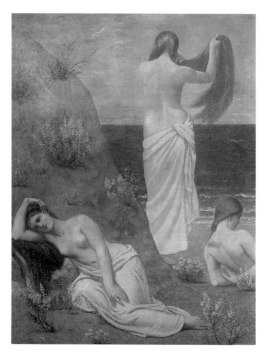

PIERRE PUVIS DE CHAVANNES (1824–1898).
Young Girls at the Seaside (decorative panel), 1879.
Oil on canvas, 80⅝ x 60⅝ in. (205 x 154 cm).

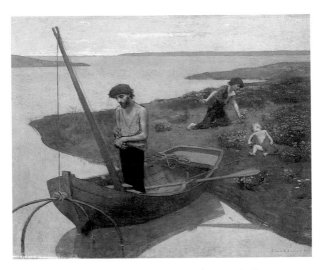

PIERRE PUVIS DE CHAVANNES (1824–1898).
The Poor Fisherman, 1881. Oil on canvas, 61 x 75⅝ in.
(155 x 192 cm).

ROMANTICISM AND REALISM

The best symbol of Romanticism remains Eugène Delacroix's sketch for *The Lion Hunt* (page 41). For Charles Baudelaire, writing in 1846, Romanticism was "the most recent, the most current expression of the beautiful"; with it was born a modernity that he defined as "the transitory, the fugitive, the contingent, half-art, the other half of which is the eternal and the immutable."

The revolution of 1848 (which inspired Honoré Daumier's *Republic,* page 42, painted for a competition organized by the new government) marked the moment when, in literature as in painting, Romanticism tipped into Realism. In 1855 the second Exposition Universelle took place in Paris: a large part of its attraction rested in the confrontation of works by Jean-Auguste-Dominique Ingres with those by Delacroix. At the same time Gustave Courbet exhibited *The Painter's Studio* (page 49) and other works in his "Pavilion of Realism," isolated on the avenue Montaigne. As he wrote in his *Manifesto of Realism:* "I simply wanted to draw the reasoned and independent feeling of my own individuality from complete knowledge of the tradition. To know in order to be able to do, this was my thought."

One of Courbet's innovations consisted in painting "trivial" subjects in large formats, conferring dignity on modern subjects in order to compete with history painting. Realist themes often focused on social analysis, initially of the peasant world. The entire political gamut was eventually represented, from social conservatism (in 1859, Emperor Napoleon III bought Jules Breton's *Calling in of the Gleaners,* page 54) to progressivism.

In the case of landscape painting, diverse movements were even more closely intertwined. Within Orientalism, periods of work that was "all imagination," according to Eugène Fromentin, and of work that was "all observation" followed one another. Delacroix found an antiquity alive and well in the Orient, while Camille Corot in Rome produced modern versions of the classical landscape, reviving the pastoral scene. The pantheist Théodore Rousseau exemplified a barely perceptible passage from Romanticism to the Barbizon school, whose other members included Charles-François Daubigny and Jean-François Millet. The principle of the latter, which was to paint from nature, was soon to be adopted by the Impressionists Frédéric Bazille and Claude Monet, who were also active in Barbizon.

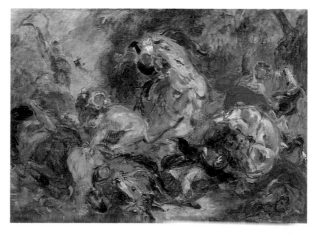

Eugène Delacroix (1798–1863).
The Lion Hunt (sketch), 1854. Oil on canvas,
33⅞ x 45⅜ in. (86 x 115 cm).

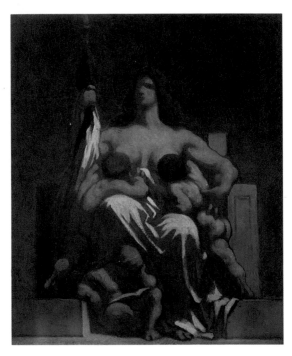

HONORÉ DAUMIER (1808–1879).
The Republic (sketch), 1848. Oil on canvas,
28⅝ x 23⅝ in. (73 x 60 cm).

HONORÉ DAUMIER (1808–1879).
The Laundress, 1863. Oil on wood, 19⅜ x 13 in.
(49 x 33 cm).

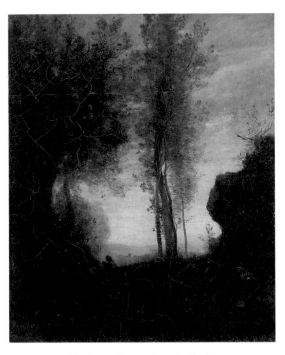

CAMILLE COROT (1796–1875).
Seated Goatherd, Playing a Flute in a Clearing, c. 1856–57.
Oil on canvas, 39⅜ x 33½ in. (100 x 85 cm).

CAMILLE COROT (1796–1875).
The Artist's Studio, Young Woman with a Mandolin, c. 1865.
Oil on canvas, 22⅛ x 18⅛ in. (56 x 46 cm).

Rosa Bonheur (1822–1899).
Ploughing in the Nivernais Region, 1849. Oil on canvas,
52¾ x 102⅜ in. (134 x 260 cm).

CHARLES-FRANÇOIS DAUBIGNY (1817–1878).
Harvest, 1851. Oil on canvas,
53⅛ x 77¼ in. (135 x 196 cm).

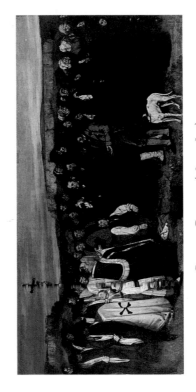

GUSTAVE COURBET (1819–1877).
Burial at Ornans, 1849–50. Oil on canvas,
10 ft. 3½ in. x 21 ft. 11 in. (3.15 x 6.68 m).

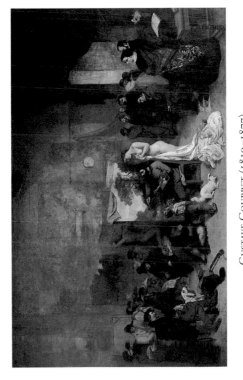

GUSTAVE COURBET (1819–1877).
The Painter's Studio: Allegory of Seven Years of My Artistic and Moral Life,
1854–55. Oil on canvas, 11 ft. 9⅝ in. x 19 ft. 7¼ in. (3.61 x 5.98 m).

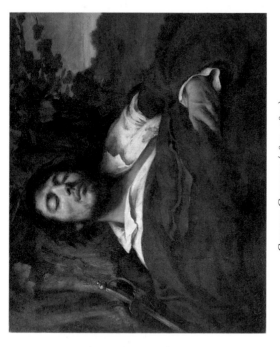

GUSTAVE COURBET (1819–1877).
The Wounded Man, 1844–54. Oil on canvas,
31⅞ x 38¼ in. (81 x 97 cm).

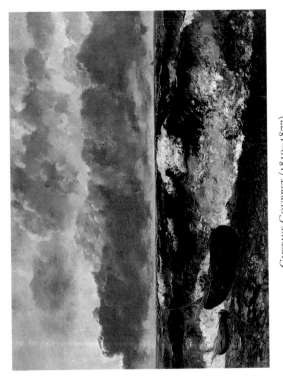

GUSTAVE COURBET (1819–1877).
The Wave, 1870 Oil on canvas,
46⅛ x 63 in. (117 x 160 cm).

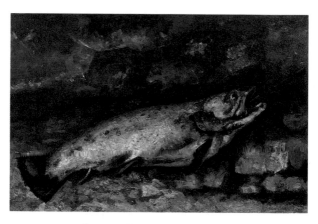

GUSTAVE COURBET (1819–1877).
The Trout, 1873. Oil on canvas,
25⅝ x 38⅝ in. (65 x 98 cm).

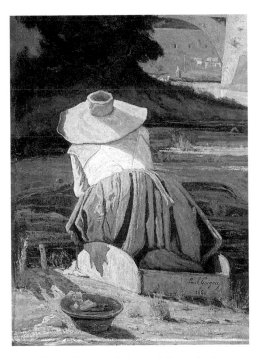

PAUL-CAMILLE GUIGOU (1834–1871).
The Washerwoman, 1860. Oil on canvas,
31⅞ x 23¼ in. (81 x 59 cm).

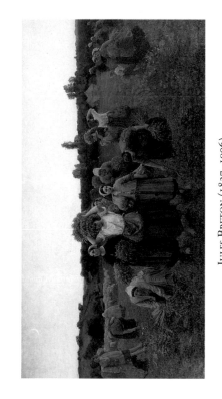

JULES BRETON (1827–1906).
The Calling in of the Gleaners, 1859. Oil on canvas,
35⅜ x 69⅜ in. (90 x 176 cm).

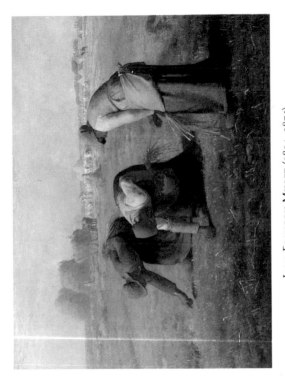

JEAN-FRANÇOIS MILLET (1814–1875).
The Gleaners, 1857. Oil on canvas,
32⅝ × 43⅝ in. (83 × 111 cm).

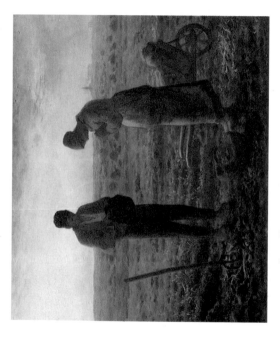

JEAN-FRANÇOIS MILLET (1814–1875).
The Angelus, 1857–59. Oil on canvas, 21⅝ x 26 in. (55 x 66 cm).

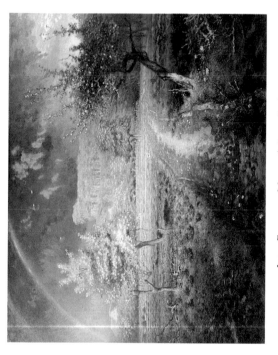

JEAN-FRANÇOIS MILLET (1814–1875).
Spring, 1868–73. Oil on canvas, 33⅞ x 43⅝ in. (86 x 111 cm).

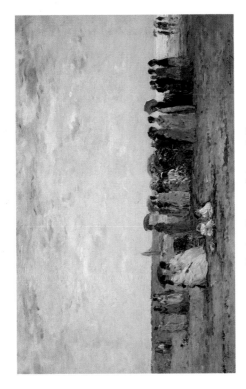

EUGÈNE BOUDIN (1824–1898).
Bathers on the Beach at Trouville, 1869. Oil on wood,
12¼ x 18⅞ in. (31 x 48 cm).

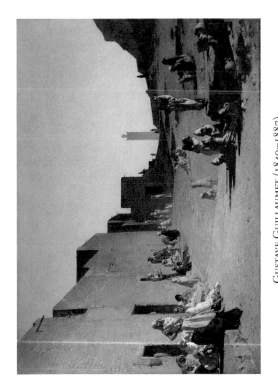

GUSTAVE GUILLAUMET (1840–1887).
Laghouat, Algerian Sahara, 1879. Oil on canvas,
48 x 71¼ in. (122 x 181 cm).

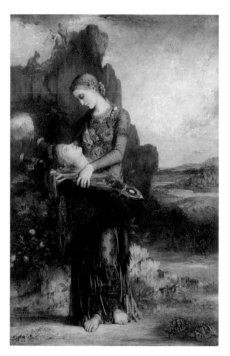

GUSTAVE MOREAU (1826–1898).
Orpheus, 1865. Oil on wood, 60⅝ x 39 in.
(154 x 99 cm).

GUSTAVE DORÉ (1832–1883).
The Enigma, 1871. Oil on canvas, 51¼ x 76¾ in.
(130 x 195 cm).

JAMES TISSOT (1836–1902).
Portrait of Mlle. L. L., or *Young Woman in a Red Jacket,* 1864.
Oil on canvas, 48¾ x 39 in. (124 x 99 cm).

ALFRED STEVENS (1823–1906).
The Bath, c. 1867. Oil on canvas, 29⅛ x 36⅝ in.
(74 x 93 cm).

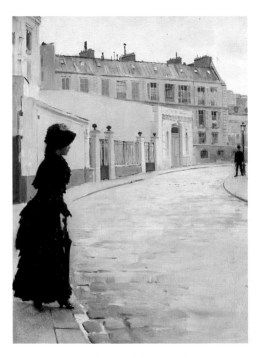

JEAN BÉRAUD (1848–1935).
The Wait, n.d. Oil on canvas, 22 x 15⅜ in.
(56 x 39 cm).

ALFRED ROLL (1846–1919).
Manda Lamétrie, Farmwife, 1887. Oil on canvas,
84⅜ x 63⅜ in. (214 x 161 cm).

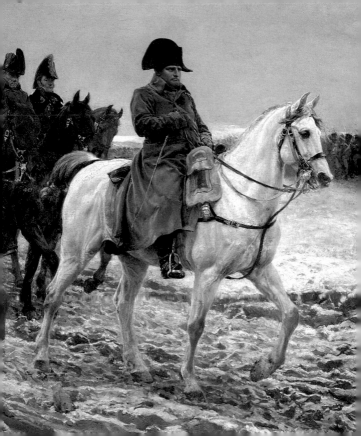

HISTORY PAINTING AND
OFFICIAL PORTRAITS

Starting in the eighteenth century and continuing through the nineteenth, the Salons (exhibitions held by the Académie Royale de Peinture et de Sculpture) became one of the main events of public artistic life in Paris. The works were selected by a jury that, after the First Empire, was made up exclusively of members of the Académie. Because the academic style was considered "rational," it could be transmitted from teacher to student, and painters followed a highly regulated curriculum that included study at the Ecole des Beaux-Arts in Paris and, for a select few, at the Villa Medici in Rome.

One example of the perpetuation of tradition through education is François-Edouard Picot, a student of Jacques-Louis David's who was famous for his teaching and for his decorations of Parisian churches. First in his studio and then at the Beaux-Arts, Picot trained future prizewinners in painting, including not only Paul Baudry, Alexandre Cabanel, and William Bouguereau but also Gustave Guillaumet and even Gustave Moreau.

There were other, sometimes surprising points of contact that enabled innovative artists to prepare for future battle through exposure to traditional milieux:

Charles Gleyre's studio, a kind of preparatory class for the Beaux-Arts, was attended by Claude Monet, Pierre-Auguste Renoir, and Alfred Sisley; Edgar Degas, Eugène Delacroix, and Moreau were all students at the Beaux-Arts. In addition, there were private courses at the Académie Julian, from which the Nabis and Henri Matisse emerged, and at the Académie Suisse.

The "historical" subjects presented in this chapter, which were sometimes taken to unexpected heights (see, for example, Edouard Detaille's *Dream,* page 77), are complemented by a variety of portraits. These range from the man of science (*Pasteur,* page 79) to the fin-de-siècle dandy Robert de Montesquiou (page 81)—who, along with Oscar Wilde's Dorian Gray and Joris-Karl Huysmans's Des Esseintes, inspired the Baron de Charlus in Marcel Proust's *Remembrance of Things Past.*

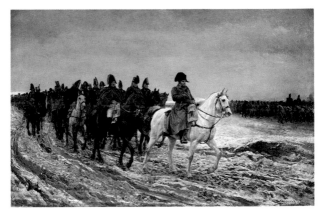

ERNEST MEISSONIER (1815–1891).
Campaign in France, 1814, 1864. Oil on wood,
20⅛ x 29⅞ in. (51 x 76 cm).

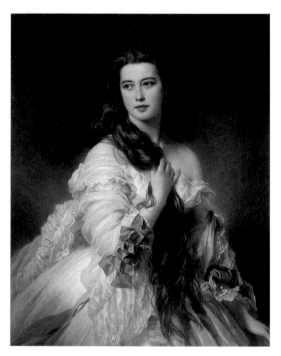

Franz-Xaver Winterhalter (1805–1873).
Madame Barbe de Rimsky-Korsakov, 1864. Oil on canvas,
46⅛ x 35⅜ in. (117 x 90 cm).

CAROLUS-DURAN (1837–1917).
Lady with a Glove, 1869. Oil on canvas,
89¾ x 64⅝ in. (228 x 164 cm).

LÉON BONNAT (1833–1922).
Madame Pasca, 1874. Oil on canvas,
87⅜ x 52 in. (222 x 132 cm).

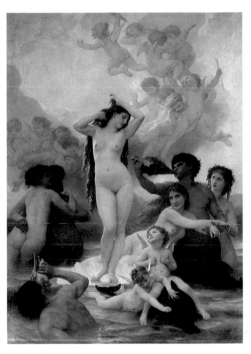

WILLIAM BOUGUEREAU (1825–1905).
The Birth of Venus, 1879. Oil on canvas,
118⅛ x 84⅜ in. (300 x 215 cm).

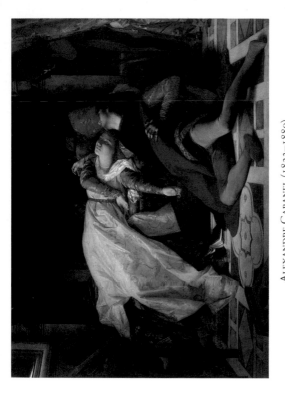

ALEXANDRE CABANEL (1823–1889).
The Death of Francesca da Rimini and Paolo Malatesta, 1870.
Oil on canvas, 72⅜ x 100¾ in. (184 x 255 cm).

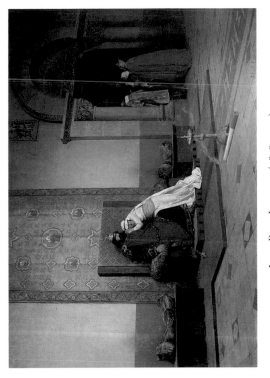

JEAN-PAUL LAURENS (1838–1921).
The Excommunication of Robert the Pious in 998, 1875.
Oil on canvas, 51¼ x 85¾ in. (130 x 218 cm).

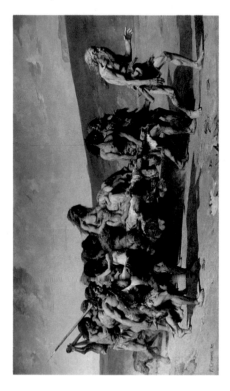

Fernand Cormon (1845–1924).
Cain, 1880. Oil on canvas, 12 ft. 4¾ in. x 22 ft. 10¾ in.
(3.8 x 7 m).

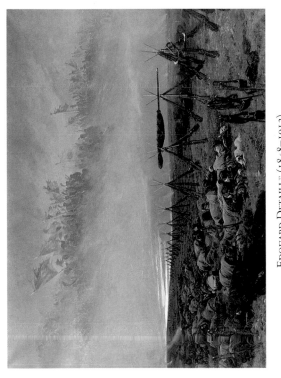

EDOUARD DETAILLE (1848–1912).
The Dream, 1888. Oil on canvas, 9 ft. 9⅝ in. x 13 ft. 1¼ in. (3 x 4 m).

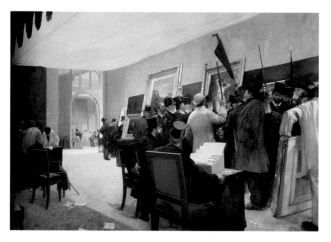

HENRI GERVEX (1852–1929).
A Painting Jury, 1885. Oil on canvas,
9 ft. 9⅝ in. x 13 ft. 8⅜ in. (2.99 x 4.19 m).

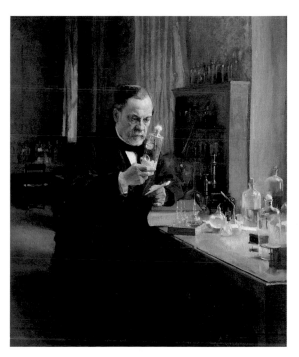

ALBERT EDELFELT (1854–1905).
Louis Pasteur, 1885. Oil on canvas,
60⅝ x 49⅝ in. (154 x 126 cm).

ALBERT BESNARD (1849–1934).
Madame Roger Jourdain, 1886. Oil on canvas,
78⅝ x 60¼ in. (200 x 153 cm).

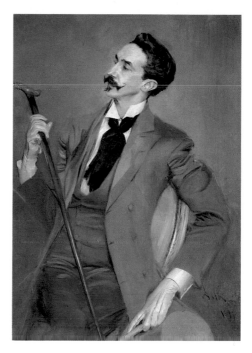

GIOVANNNI BOLDINI (1842–1931).
Count Robert de Montesquiou, 1897. Oil on canvas,
63 x 32⅜ in. (160 x 82 cm).

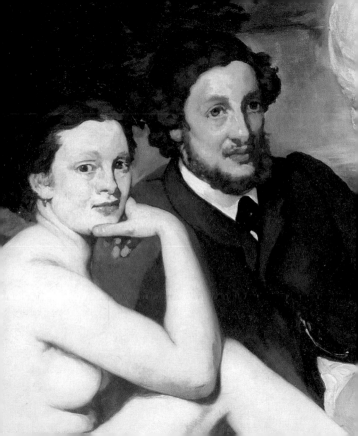

THE NEW PAINTING OF
THE 1860s AND IMPRESSIONISM

Rejection from the Salons appears, in retrospect, to have been a catalyst for the conception of a new style of painting. In 1863, faced with a controversy caused by the rejection of numerous works by the Salon jury, Napoleon III created the Salon des Refusés, whose scandal over Edouard Manet's *Luncheon on the Grass* (opposite and page 86) was amplified, two years later at the official Salon, by outrage over his *Olympia* (page 87).

Similarly, again in response to the rejection of their works by the Salon, a group of painters (derisively baptized "Impressionists") organized eight independent exhibitions between 1874 and 1886. Although Manet never participated in their shows, he drew nearer to the group's aesthetic after the Franco-Prussian War of 1870. The aesthetic unity within the group seems to have been compromised as early as the 1879 exhibition, and after 1880 Paul Cézanne, who was represented in the initial exhibitions, distanced himself from the group.

There were profound differences in the work of these artists. Strictly speaking, the "pure" Impressionism of Pierre-Auguste Renoir, Claude Monet, Camille Pissarro, and Alfred Sisley marked the culmination of the

endeavor to render a modern vision of the ephemeral by recording the transitory aspect of light, an endeavor well suited to working in series. But these works have little in common with those by, say, Edgar Degas, whose compositions are oriented toward a kind of choreography that became openly theatrical in *In a Café* (also known as *The Absinthe Drinker,* page 101). And what did any of these have in common with the "sensation" sought by Cézanne, who undertook to "treat nature through the cylinder, the sphere and the cone"?

Beginning in 1880, the "pure" Impressionists were concerned with producing a more constructed art; Pissarro, for example, embarked on a Pointillist phase. Each pursued a solitary evolution, sometimes late in his career, as in the cases of Renoir and Monet. Did they share the desire expressed by Cézanne to make Impressionism into "something solid and lasting, like the art in museums"?

Despite the incomprehension of the public and sometimes even of their sympathizers, the Impressionists had support from collectors like Jean-Baptiste Faure and dealers like Paul Durand-Ruel. One who went on to support subsequent generations was Ambroise Vollard, who was dealer first to Manet and Cézanne, then eventually to Henri Rousseau, Henri Matisse, and Pablo Picasso.

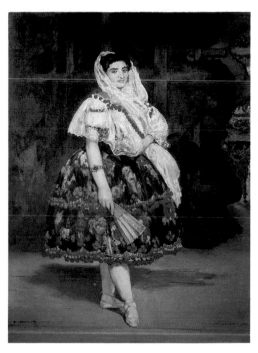

EDOUARD MANET (1832–1883).
Lola de Valence, 1862. Oil on canvas,
48⅜ x 36 in. (123 x 92 cm).

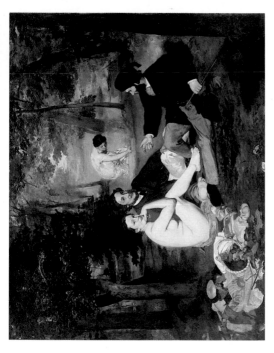

EDOUARD MANET (1832–1883).
Luncheon on the Grass, 1863. Oil on canvas,
81⅞ x 103⅞ in. (208 x 264 cm).

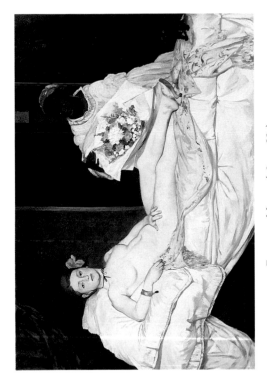

EDOUARD MANET (1832–1883).
Olympia, 1863. Oil on canvas, 51 1/4 x 74 3/4 in. (130 x 190 cm).

87

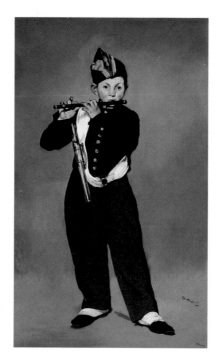

EDOUARD MANET (1832–1883).
The Fife Player, 1866. Oil on canvas,
63⅜ x 38¼ in. (161 x 97 cm).

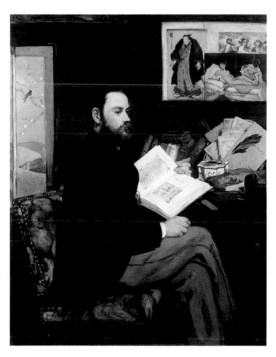

EDOUARD MANET (1832–1883).
Emile Zola, 1868. Oil on canvas, 57½ x 44⅞ in.
(146 x 114 cm).

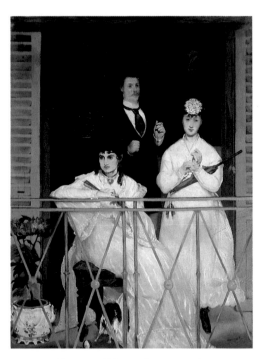

EDOUARD MANET (1832–1883).
The Balcony, 1868–69. Oil on canvas,
66⅞ x 48¾ in. (170 x 124 cm).

EDOUARD MANET (1832–1883).
Stéphane Mallarmé, 1876. Oil on canvas,
10⅝ x 14¼ in. (27 x 36 cm).

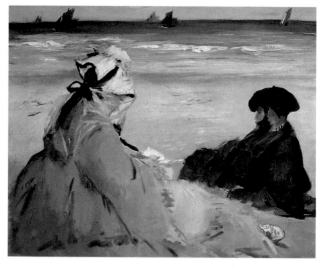

EDOUARD MANET (1832–1883).
On the Beach, 1873. Oil on canvas,
23¼ x 28¾ in. (59 x 73 cm).

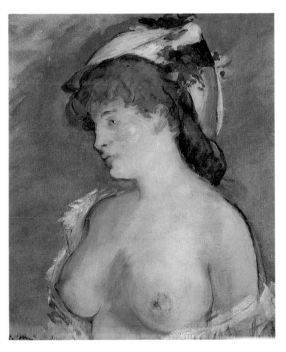

EDOUARD MANET (1832–1883).
Blond Woman with Bare Breasts, c. 1878. Oil on canvas,
24⅜ x 20½ in. (62 x 52 cm).

EDOUARD MANET (1832–1883).
The Escape of Rochefort, 1880–81. Oil on canvas,
31½ x 28⅝ in. (80 x 73 cm).

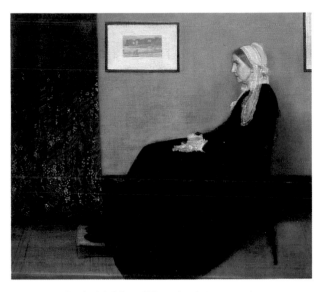

JAMES MCNEILL WHISTLER (1834–1903).
Arrangement in Grey and Black, No. 1, or *The Artist's Mother,*
1871. Oil on canvas, 56⅝ x 63¾ in. (144 x 162 cm).

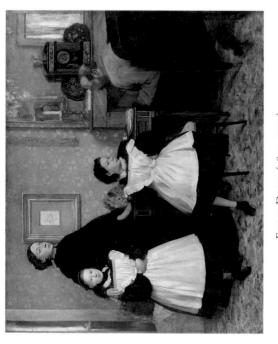

EDGAR DEGAS (1834–1917).
The Bellelli Family, 1858–67. Oil on canvas,
78⅞ x 98⅜ in. (200 x 250 cm).

EDGAR DEGAS (1834–1917).
Racehorses in Front of the Grandstand, c. 1866–68.
Oil on paper on canvas, 18½ x 24 in. (46 x 61 cm).

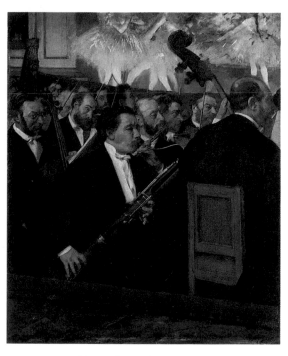

EDGAR DEGAS (1834–1917).
The Orchestra of the Opéra, c. 1870. Oil on canvas,
22 x 18⅛ in. (56 x 46 cm).

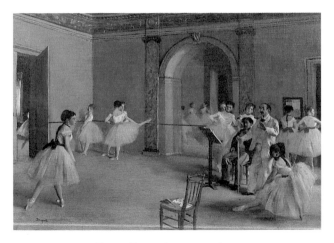

EDGAR DEGAS (1834–1917).
The Dance Class at the Opéra, rue Le Peletier, 1872.
Oil on canvas, 12⅝ x 18⅛ in. (32 x 46 cm).

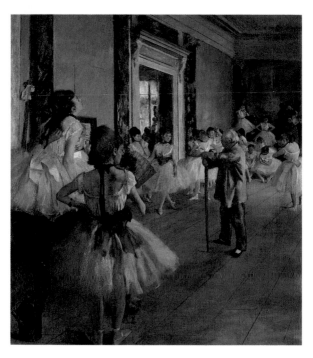

EDGAR DEGAS (1834–1917).
The Dance Class, c. 1873–76. Oil on canvas,
33½ x 29½ in. (85 x 75 cm).

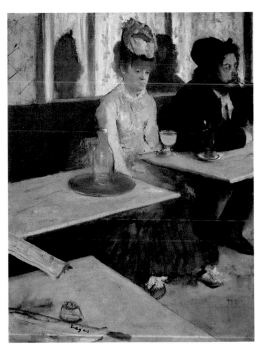

EDGAR DEGAS (1834–1917).
In a Café, or *The Absinthe Drinker*, c. 1875–76.
Oil on canvas, 36¼ x 26¾ in. (92 x 68 cm).

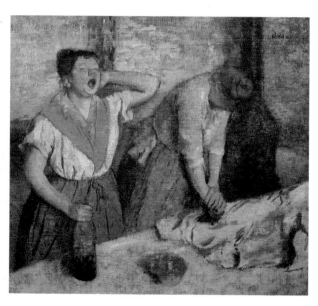

EDGAR DEGAS (1834–1917).
Women Ironing, c. 1884–86. Oil on canvas,
29⅞ x 31¾ in. (76 x 81 cm).

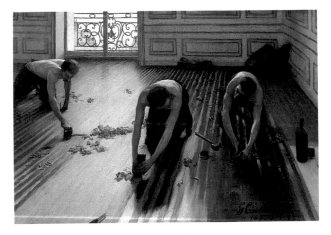

GUSTAVE CAILLEBOTTE (1848–1894).
The Floor Scrapers, 1875. Oil on canvas,
40⅛ x 57⅜ in. (102 x 146 cm).

Henri Fantin-Latour (1836–1904).
Homage to Delacroix, 1864. Oil on canvas,
62⅞ x 88½ in. (160 x 225 cm).

HENRI FANTIN-LATOUR (1836–1904).
An Atelier in the Batignolles, 1870. Oil on canvas,
80⅜ x 107⅞ in. (204 x 273 cm).

HENRI FANTIN-LATOUR (1836–1904).
Corner of the Table, 1872. Oil on canvas, 62⅞ x 88½ in. (160 x 225 cm).

FRÉDÉRIC BAZILLE (1841–1870).
Family Reunion, 1867. Oil on canvas, 59¾ x 90⅝ in. (152 x 230 cm).

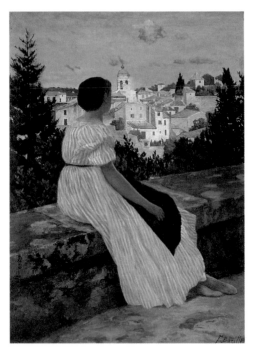

FRÉDÉRIC BAZILLE (1841–1870).
The Pink Dress, or *View of Castelnau-le-Lez, Hérault,* 1864.
Oil on canvas, 57⅞ x 43⅜ in. (147 x 110 cm).

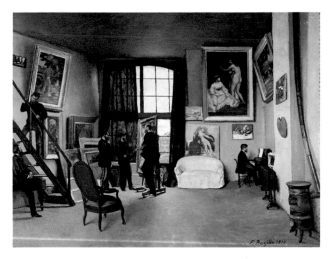

FRÉDÉRIC BAZILLE (1841–1870).
The Artist's Studio, 1870. Oil on canvas,
38⅝ x 50⅜ in. (98 x 128 cm).

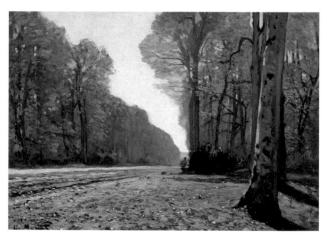

CLAUDE MONET (1840–1926).
The Chailly Highway, c. 1865. Oil on canvas,
17⅜ x 23¼ in. (43.5 x 59 cm).

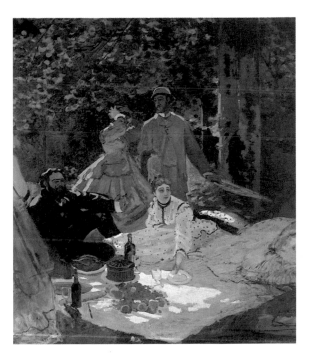

CLAUDE MONET (1840–1926).
Luncheon on the Grass, 1865–66. Oil on canvas,
97⅝ x 85⅜ in. (248 x 217 cm).

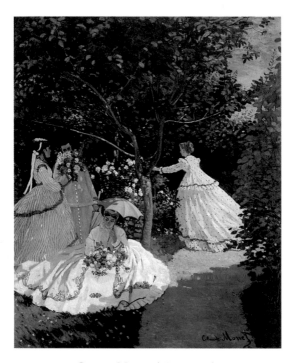

CLAUDE MONET (1840–1926).
Women in a Garden, 1867. Oil on canvas,
100⅜ x 80⅝ in. (255 x 205 cm).

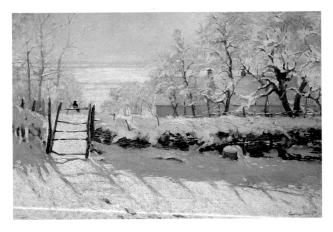

CLAUDE MONET (1840–1926).
The Magpie, winter 1868–69. Oil on canvas,
35 x 51¼ in. (89 x 130 cm).

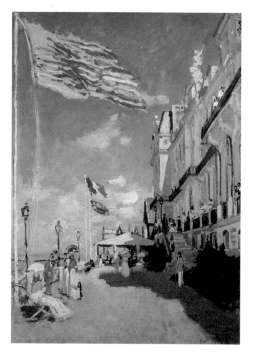

CLAUDE MONET (1840–1926).
The Hôtel des Roches-Noires, Trouville, 1870.
Oil on canvas, 31⅞ x 22¾ in. (81 x 58 cm).

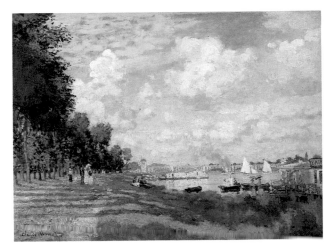

CLAUDE MONET (1840–1926).
Argenteuil Basin, c. 1872. Oil on canvas,
23⅝ x 31½ in. (60 x 80 cm).

CLAUDE MONET (1840–1926).
Poppies, 1873. Oil on canvas, 19⅝ x 25⅝ in. (50 x 65 cm).

CLAUDE MONET (1840–1926).
Luncheon (decorative panel), c. 1873. Oil on canvas,
63 × 79⅛ in. (160 x 201 cm).

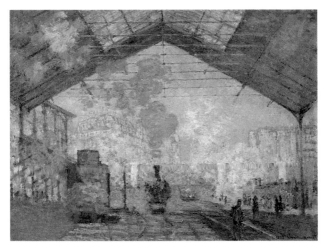

CLAUDE MONET (1840–1926).
Saint-Lazare Station, 1877. Oil on canvas,
29½ x 40⅞ in. (75 x 104 cm).

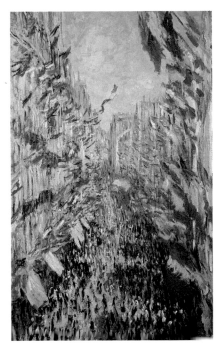

CLAUDE MONET (1840–1926).
Rue Montorgueil, Paris: Festival of June 30, 1878, 1878.
Oil on canvas, 31⅞ x 19⅝ in. (81 x 50 cm).

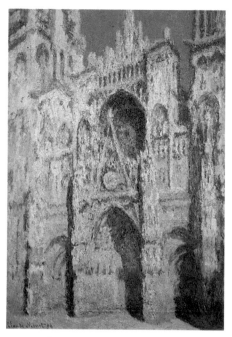

CLAUDE MONET (1840–1926).
*Rouen Cathedral: The Portal and the Saint-Romain Tower
in Full Sun, Harmony in Blue and Gold*, 1893.
Oil on canvas, 42⅛ x 28⅝ in. (107 x 73 cm).

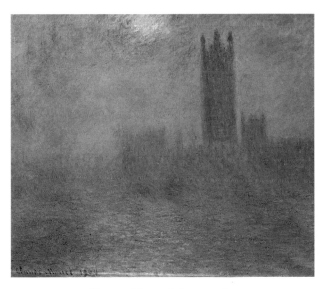

CLAUDE MONET (1840–1926).
The Houses of Parliament, London, 1904. Oil on canvas,
31⅞ x 36¼ in. (81 x 92 cm).

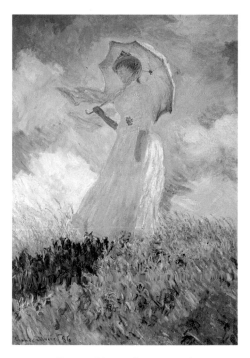

CLAUDE MONET (1840–1926).
Woman with Parasol Turned toward the Left, 1886.
Oil on canvas, 51⅝ x 34⅝ in. (131 x 88 cm).

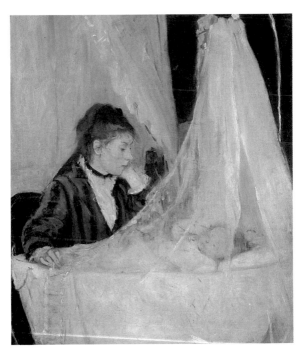

BERTHE MORISOT (1841–1895).
The Cradle, 1872. Oil on canvas,
22⅛ x 18⅛ in. (56 x 46 cm).

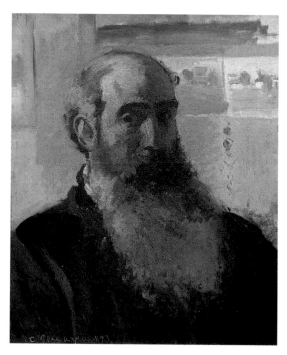

CAMILLE PISSARRO (1830–1903).
Self-Portrait, 1873. Oil on canvas,
22⅛ x 18⅛ in. (56 x 46 cm).

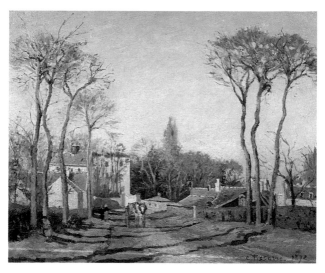

CAMILLE PISSARRO (1830–1903).
The Entrance to the Village of Voisins, 1872. Oil on canvas,
18⅛ x 21⅝ in. (46 x 55 cm).

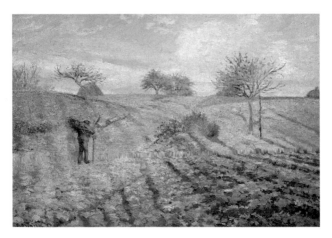

CAMILLE PISSARRO (1830–1903).
Hoarfrost, 1873. Oil on canvas, 25⅝ x 36⅝ in. (65 x 93 cm).

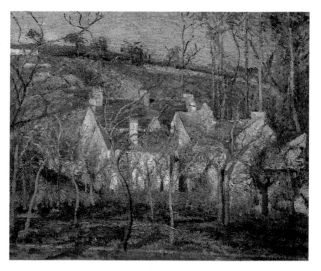

CAMILLE PISSARRO (1830–1903).
Red Roofs, a Corner of the Village in Winter, 1877.
Oil on canvas, 21⅜ x 25⅝ in. (54 x 65 cm).

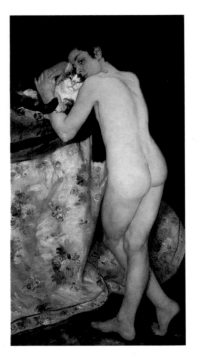

PIERRE-AUGUSTE RENOIR (1841–1919).
Young Boy with a Cat, 1868–69. Oil on canvas,
48⅜ x 26 in. (123 x 66 cm).

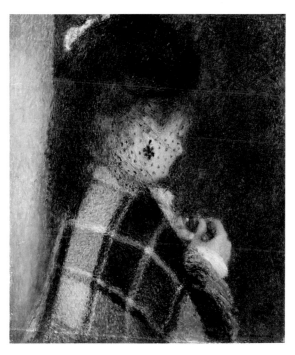

PIERRE-AUGUSTE RENOIR (1841–1919).
Young Woman with a Veil, c. 1875. Oil on canvas,
24 x 20⅛ in. (61 x 51 cm).

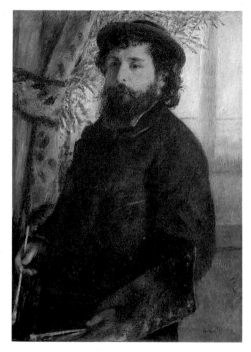

PIERRE-AUGUSTE RENOIR (1841–1919).
Claude Monet, 1875. Oil on canvas,
33½ x 23⅝ in. (85 x 60 cm).

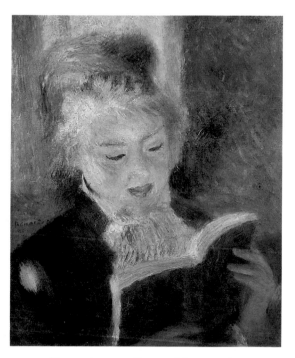

PIERRE-AUGUSTE RENOIR (1841–1919).
Woman Reading, c. 1874–76. Oil on canvas,
18⅛ x 15 in. (46 x 38 cm).

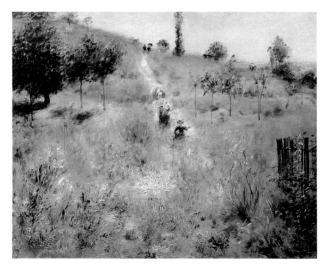

PIERRE-AUGUSTE RENOIR (1841–1919).
Path Leading to the High Grass, c. 1875(?). Oil on canvas,
28⅝ x 36¼ in. (92 x 73 cm).

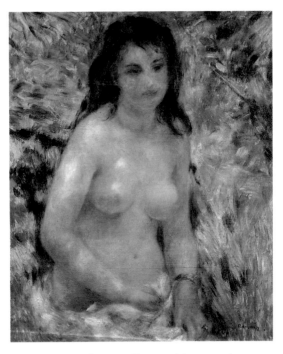

PIERRE-AUGUSTE RENOIR (1841–1919).
Study for Nude in Sunlight, c. 1875–76. Oil on canvas,
31⅞ x 25⅝ in. (81 x 65 cm).

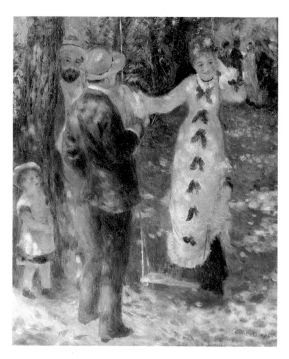

PIERRE-AUGUSTE RENOIR (1841–1919).
The Swing, 1876. Oil on canvas,
36¼ x 28⅝ in. (92 x 73 cm).

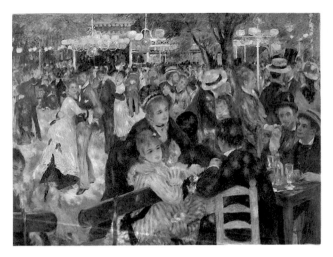

PIERRE-AUGUSTE RENOIR (1841–1919).
Dance at the Moulin de la Galette, Montmartre, 1876.
Oil on canvas, 51⅝ x 68⅞ in. (131 x 175 cm).

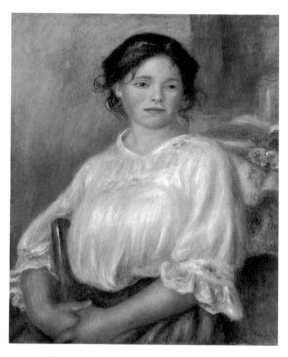

PIERRE-AUGUSTE RENOIR (1841–1919).
Young Girl, Seated, c. 1909. Oil on canvas,
25⅝ x 21⅜ in. (65 x 54 cm).

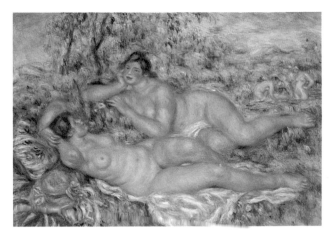

PIERRE-AUGUSTE RENOIR (1841–1919).
Bathers, c. 1918–19. Oil on canvas, 43⅜ x 63 in.
(110 x 160 cm).

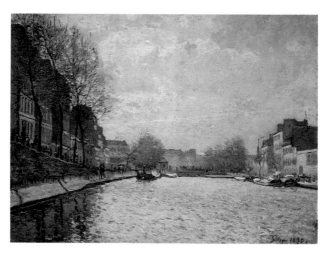

ALFRED SISLEY (1839–1899).
View of the Saint-Martin Canal, 1870. Oil on canvas,
19⅝ x 25⅝ in. (50 x 65 cm).

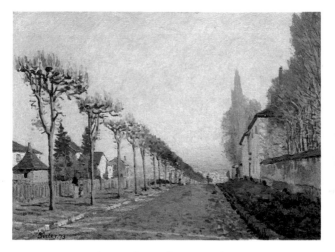

ALFRED SISLEY (1839–1899).
Chemin de la Machine, Louveciennes, 1873. Oil on canvas,
21⅝ x 28⅝ in. (54 x 73 cm).

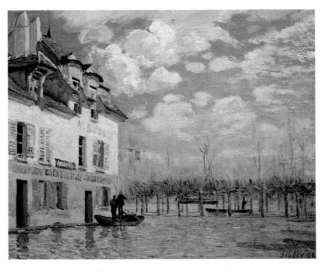

ALFRED SISLEY (1839–1899).
The Boat During the Flood, 1876. Oil on canvas,
19⅝ x 24 in. (50 x 61 cm).

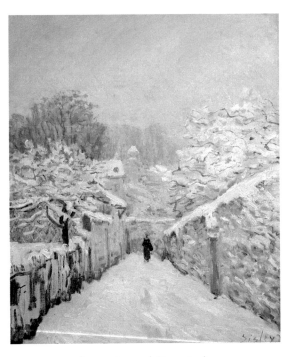

ALFRED SISLEY (1839–1899).
Snow at Louveciennes, 1878. Oil on canvas,
24 x 19⅝ in. (61 x 50 cm).

PAUL CÉZANNE (1839–1906).
Mary Magdalene, c. 1869. Oil on canvas,
65 x 49¼ in. (165 x 125 cm).

PAUL CÉZANNE (1839–1906).
House of the Hanged Man, 1873. Oil on canvas,
21⅝ x 26 in. (55 x 66 cm).

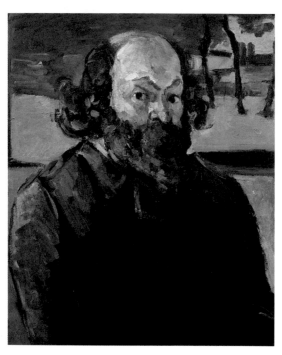

PAUL CÉZANNE (1839–1906).
Self-Portrait, c. 1873–76. Oil on canvas,
25¼ x 20¾ in. (64 x 53 cm).

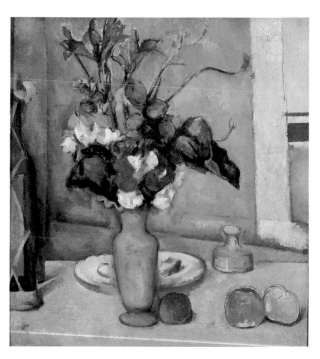

PAUL CÉZANNE (1839–1906).
The Blue Vase, c. 1885–87. Oil on canvas,
24 x 19⅝ in. (61 x 50 cm).

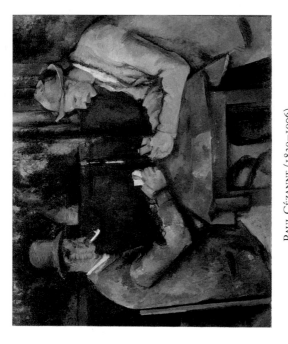

PAUL CÉZANNE (1839–1906).
The Card Players, c. 1390–95. Oil on canvas, 18½ x 22⅞ in. (47 x 57 cm).

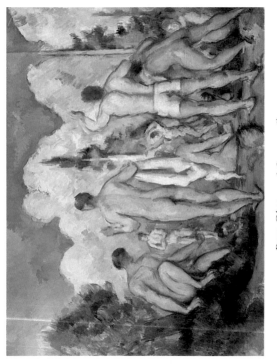

PAUL CÉZANNE (1839–1906).
Bathers, c. 1890–92. Oil on canvas, 23⅝ x 32⅞ in. (60 x 82 cm).

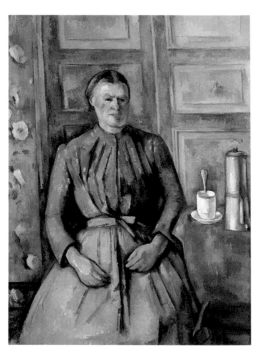

PAUL CÉZANNE (1839–1906).
Woman with a Coffee Pot, c. 1890–95. Oil on canvas,
51¼ x 37¾ in. (130 x 96 cm).

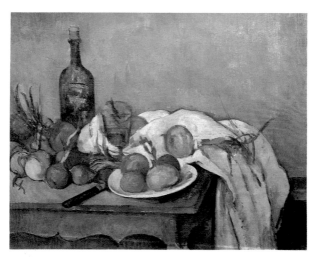

PAUL CÉZANNE (1839–1906).
Still Life with Onions, c. 1895. Oil on canvas,
26 x 32⅜ in. (66 x 82 cm).

AFTER IMPRESSIONISM

The end of the nineteenth century witnessed a multitude of manifestos, of "isms," of movements destined to split apart, and of innumerable unclassifiable artists, such as Vincent van Gogh, who bore the seeds of Fauvism and of Expressionism.

The period also witnessed a proliferation of exhibition spaces. In Belgium the annual salon of Les Vingt was originated in 1883 by James Ensor, Théo van Rysselberghe, Fernand Khnopff, and Octave Maus. In France in 1884, Odilon Redon, Georges Seurat, and Paul Signac founded the Salon des Indépendants, where the Nabis, the Symbolists, and later the Cubists exhibited. The Salon d'Automne, also in Paris, showed Art Nouveau beginning in 1903, the Fauves in 1905, and major retrospectives of Paul Gauguin in 1906 and Paul Cézanne in 1907. The final Impressionist exhibition, in 1886, marked the emergence of the Neo-Impressionists, with Seurat's *A Sunday on La Grande Jatte.* In his dream of "art-science," the latter explored the theoretical laws of contrast and of optical blending, rendering his paintings in small dots spread out over vast compositions.

In 1891 Gauguin made his first journey to Tahiti; his

simultaneously ethnographic and spiritual quest was embodied in paintings that incorporated an eclectic array of quotations from other artists. He had time before his death to transmit his own heritage: Paul Sérusier's *The Talisman* (page 180), fruit of a lesson by Gauguin in Pont-Aven, France, in 1888, became an object of veneration for the Nabis. Despite belonging to the latter group, Pierre Bonnard appears to be an isolated figure at Orsay, as do Gustav Klimt and Edvard Munch. A true "prophet" who went against the grain, Bonnard constantly reinvented himself in the course of his long career.

The symbolic moment of transition to the twentieth century is Henri Matisse's *Luxe, calme et volupté* (page 217). Having joined Signac in Saint-Tropez in 1904, Matisse painted this ultimate Pointillist work, in which space is constructed from broad surfaces of pure color organized according to a newly reinvented perspective. Matisse painted this work in homage to Charles Baudelaire (the title comes from one of his poems) and to Cézanne, thus demonstrating the ambiguity of the nineteenth century as a two-faced Janus looking both forward and back.

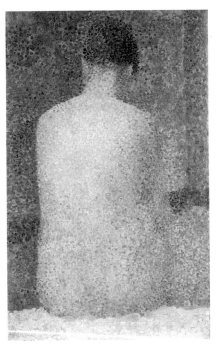

GEORGES SEURAT (1859–1891).
Model from Behind, 1887. Oil on wood,
9½ x 5⅞ in. (24 x 15 cm).

GEORGES SEURAT (1859–1891).
Port-en-Bessin, Outer Harbour at High Tide, 1888.
Oil on canvas, 26⅜ x 32⅜ in. (67 x 82 cm).

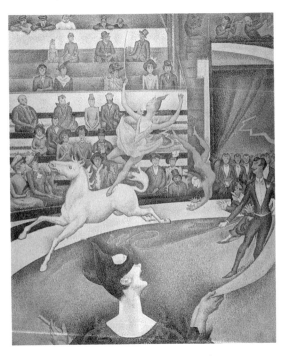

GEORGES SEURAT (1859–1891).
The Circus, 1891. Oil on canvas, 72¾ x 59¾ in.
(185 x 152 cm).

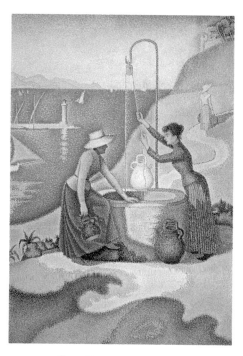

PAUL SIGNAC (1863–1935).
Women at the Well, 1892. Oil on canvas,
76¾ x 51⅝ in. (195 x 131 cm).

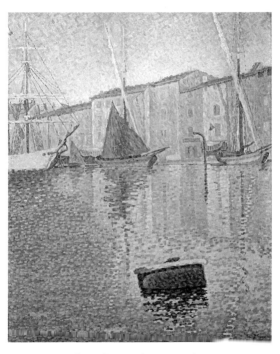

PAUL SIGNAC (1863–1935).
Red Buoy, 1895. Oil on canvas,
31⅞ x 25⅝ in. (81 x 65 cm).

THÉO VAN RYSSELBERGHE (1862–1926).
The Steersman, 1892. Oil on canvas, 23⅝ x 31½ in.
(60 x 80 cm).

HENRI-EDMOND CROSS (1856–1910).
The Golden Isles, 1891–92. Oil on canvas,
23¼ x 21⅜ in. (59 x 54 cm).

HENRI-EDMOND CROSS (1856–1910).
Woman Combing Her Hair, c. 1892. Oil on canvas,
24 x 18⅛ in. (61 x 46 cm).

Henri-Edmond Cross (1856–1910).
Evening Breeze, 1893–94. Oil on canvas,
45⅝ x 65 in. (116 x 165 cm).

MAXIMILIEN LUCE (1858–1941).
A Paris Street in May 1871, or *The Commune*, 1903–5.
Oil on canvas, 59⅛ x 88⅝ in. (150 x 225 cm).

162

André Devambez (1867–1944).
The Charge, 1901. Oil on canvas, 50 x 63¾ in. (127 x 162 cm).

George Hendrik Breitner (1857–1923).
Moonlight, c. 1887–89. Oil on canvas,
39½ x 59¾ in. (100 x 152 cm).

VALENTINE ALEXANDROVITCH SEROV (1865–1911).
Madame Lvov, 1898. Oil on canvas,
35⅜ x 23¼ in. (90 x 59 cm).

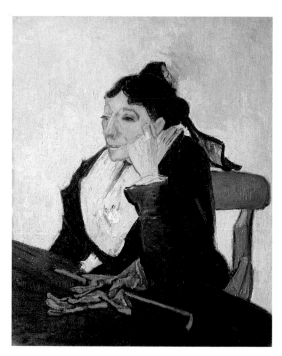

VINCENT VAN GOGH (1853–1890).
The Woman of Arles, 1888. Oil on canvas,
36¼ x 28⅝ in. (92 x 73 cm).

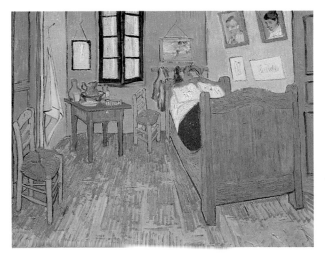

VINCENT VAN GOGH (1853–1890).
The Artist's Bedroom in Arles, 1889. Oil on canvas,
22⅜ x 29⅛ in. (57 x 74 cm).

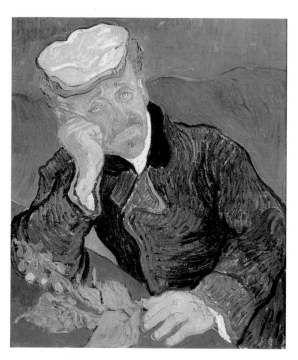

VINCENT VAN GOGH (1853–1890).
Dr. Paul Gachet, June 1890. Oil on canvas,
26¾ x 22⅜ in. (68 x 57 cm).

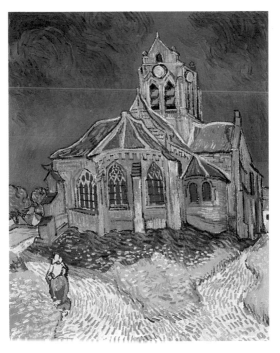

VINCENT VAN GOGH (1853–1890).
The Church at Auvers, June 1890. Oil on canvas,
37 x 29⅛ in. (94 x 74 cm).

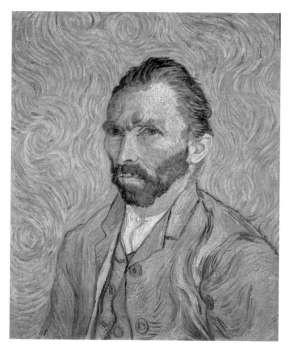

VINCENT VAN GOGH (1853–1890).
Self-Portrait, 1889. Oil on canvas, 25⅝ x 21⅜ in. (65 x 54 cm).

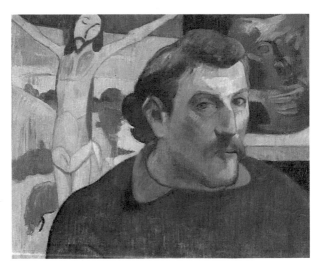

PAUL GAUGUIN (1848–1903).
Self-Portrait with Yellow Christ, 1889–90. Oil on canvas,
15 x 18⅛ in. (38 x 46 cm).

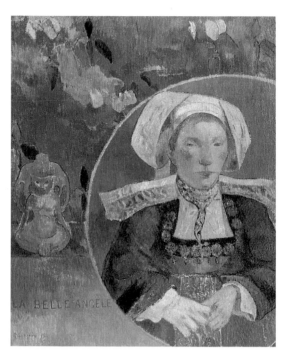

PAUL GAUGUIN (1848–1903).
The Beautiful Angèle, 1889. Oil on canvas,
36¼ x 28⅝ in. (92 x 73 cm).

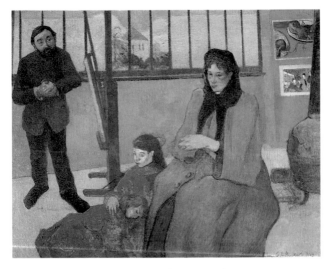

PAUL GAUGUIN (1848–1903).
Schuffenecker's Studio, or *The Schuffenecker Family,* February–
May 1889. Oil on canvas, 28⅝ x 36¼ in. (73 x 92 cm).

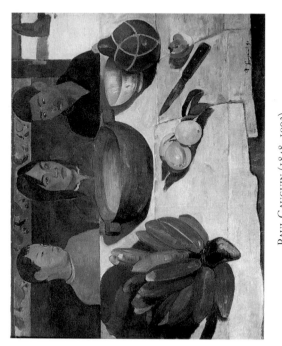

PAUL GAUGUIN (1848–1903).
The Meal, or *Bananas*, 1891. Oil on paper mounted on canvas, 28⅞ x 36¼ in. (73 x 92 cm).

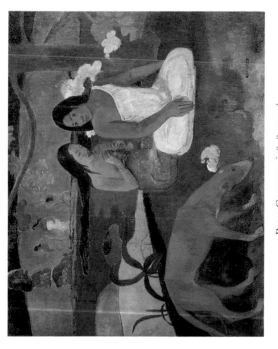

PAUL GAUGUIN (1848–1903).
Arearea, 1892. Oil on canvas, 29¼ x 37 in. (75 x 94 cm).

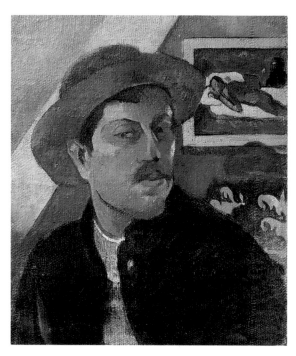

PAUL GAUGUIN (1848–1903).
Self-Portrait, c. 1893–94. Oil on canvas,
18⅛ x 15 in. (46 x 38 cm).

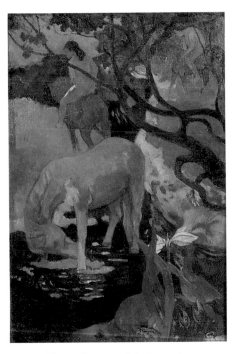

PAUL GAUGUIN (1848–1903).
The White Horse, 1898. Oil on canvas,
55⅛ x 35¾ in. (140 x 91 cm).

Emile Bernard (1868–1941).
Madeleine in the Bois d'Amour, 1888. Oil on canvas,
54⅜ x 64¼ in. (138 x 163 cm).

EMILE BERNARD (1868–1941).
Harvest by the Sea, 1891. Oil on canvas, 27⅝ x 36¼ in. (70 x 92 cm).

PAUL SÉRUSIER (1864–1927).
The Talisman, October 1888. Oil on wood,
10⅝ x 8⅜ in. (27 x 21 cm).

PAUL SÉRUSIER (1864–1927).
The Flowery Barrier, 1889. Oil on canvas,
28⅝ x 23⅝ in. (73 x 60 cm).

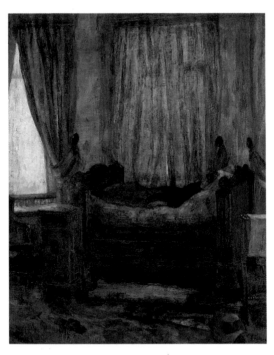

JAMES ENSOR (1860–1949).
Lady in Distress, 1882. Oil on canvas,
39⅜ x 31⅛ in. (100 x 79 cm).

AUGUST STRINDBERG (1849–1912).
Wave VII, c. 1900–1901. Oil on canvas,
22⅜ x 14¼ in. (57 x 36 cm).

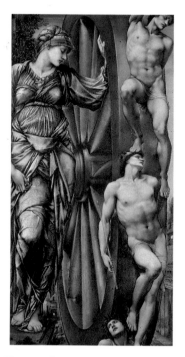

EDWARD BURNE-JONES (1833–1898).
The Wheel of Fortune, 1875–83. Oil on canvas,
78⅝ x 39⅜ in. (200 x 100 cm).

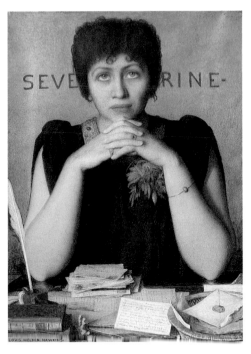

Louis Welden Hawkins (1849–1910).
Severine, n.d. Oil on canvas, 30⅜ x 21⅝ in.
(77 x 55 cm).

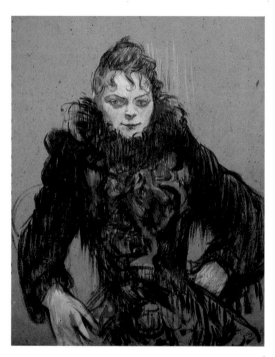

HENRI DE TOULOUSE-LAUTREC (1864–1901).
Woman with Black Boa, 1892. Oil on cardboard,
20⅞ x 16¼ in. (53 x 41 cm).

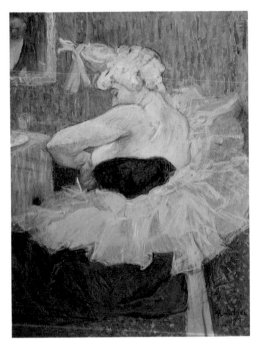

HENRI DE TOULOUSE-LAUTREC (1864–1901).
The Lady Clown Cha-U-Kao, 1895. Oil on cardboard,
25¼ x 19⅜ in. (64 x 49 cm).

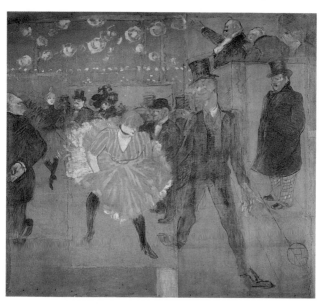

HENRI DE TOULOUSE-LAUTREC (1864–1901).
Dancers at the Moulin-Rouge (left panel for La Goulue's stall
at the Trône Fair, Paris), 1895. Oil on canvas,
117⅜ x 124⅜ in. (298 x 316 cm).

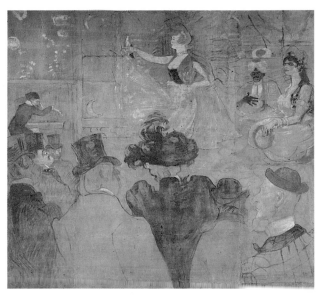

HENRI DE TOULOUSE-LAUTREC (1864–1901).
The Moorish Dance (right panel for La Goulue's stall), 1895.
Oil on canvas, 112¼ x 120⅞ in. (285 x 307 cm).

HENRI ROUSSEAU (1844–1910).
War, n.d. Oil on canvas, 44⅞ x 76¾ in. (114 x 195 cm).

HENRI ROUSSEAU (1844–1910).
The Snake Charmer, 1907. Oil on canvas, 66½ x 74⅜ in. (169 x 189 cm).

PIERRE BONNARD (1867–1947).
Intimacy, 1891. Oil on canvas, 15 x 14¼ in. (38 x 36 cm).

PIERRE BONNARD (1867–1947).
The Checked Blouse, 1892. Oil on canvas,
24 x 13 in. (61 x 33 cm).

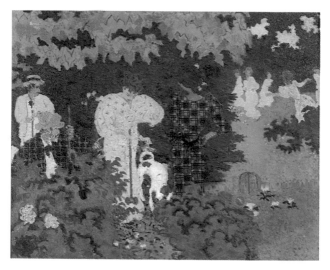

PIERRE BONNARD (1867–1947).
The Croquet Game, 1892. Oil on canvas,
51¼ x 63¾ in. (130 x 162 cm).

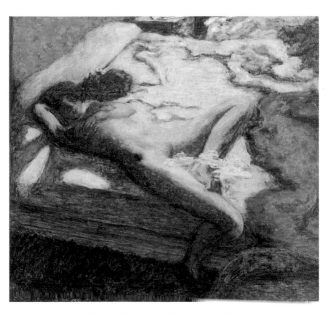

PIERRE BONNARD (1867–1947).
Lazy Nude, 1899. Oil on canvas, 37¾ x 41⅝ in.
(96 x 106 cm).

PIERRE BONNARD (1867–1947).
The Loge, 1908. Oil on canvas, 35¾ x 47¼ in.
(91 x 120 cm).

PIERRE BONNARD (1867–1947).
Portrait of the Bernheim Brothers, 1920. Oil on canvas,
65 x 61 in. (165 x 155 cm).

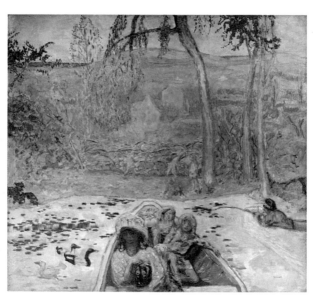

PIERRE BONNARD (1867–1947).
In the Boat, c. 1907. Oil on canvas, 109½ x 118½ in.
(278 x 301 cm).

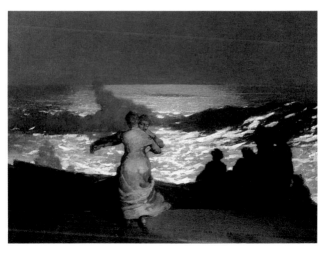

Winslow Homer (1836–1910).
Summer Night, 1890. Oil on canvas, 29⅞ x 40¼ in.
(76 x 102 cm).

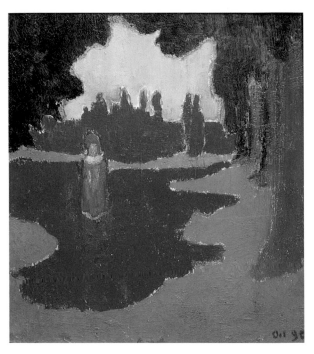

MAURICE DENIS (1870–1943).
Sunlight on the Terrace, 1890. Oil on cardboard,
9½ x 7⅞ in. (24 x 20 cm).

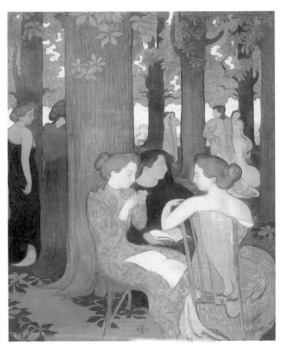

MAURICE DENIS (1870–1943).
The Muses, 1893. Oil on canvas, 67½ x 53⅞ in.
(171.5 x 137 cm).

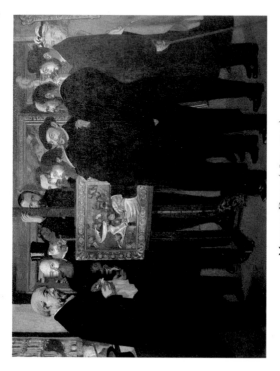

MAURICE DENIS (1870–1943).
Homage to Cézanne, 1900. Oil on canvas, 70¾ x 94½ in.
(180 x 240 cm).

EDOUARD VUILLARD (1868–1940).
In Bed, 1891. Oil on canvas, 28⅝ x 36¼ in. (73 x 92 cm).

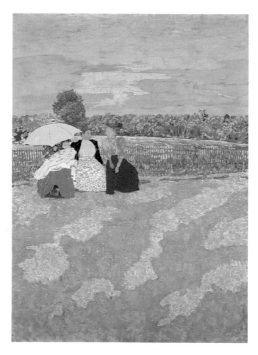

EDOUARD VUILLARD (1868–1940).
The Conversation (center panel of *Public Gardens*), 1894.
Oil on canvas, 83⅞ x 60⅝ in. (213 x 154 cm).

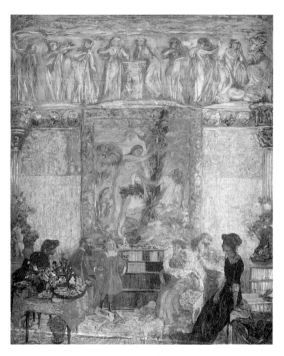

EDOUARD VUILLARD (1868–1940).
The Library, 1911. Oil on canvas,
13 ft. 1½ in. x 9 ft. 9⅝ in. (4 x 3 m).

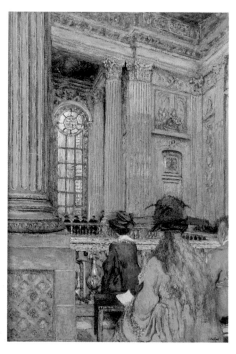

EDOUARD VUILLARD (1868–1940).
The Chapel at Versailles, 1917–19. Oil on paper on canvas,
37¾ x 26 in. (96 x 66 cm).

KERR-XAVIER ROUSSEL (1867–1944).
The Abduction of the Daughters of Leucippus, 1911.
Oil on canvas, 14 ft. 1¼ in. x 7 ft. 10¾ in. (4.3 x 2.4 m).

FÉLIX VALLOTTON (1865–1925).
Dinner by Lamplight, 1899. Oil on wood, 22³⁄₈ x 35 in. (57 x 89 cm).

Félix Vallotton (1865–1925).
The Ball, 1899. Oil on cardboard on wood, 18⅞ x 24 in (48 x 61 cm).

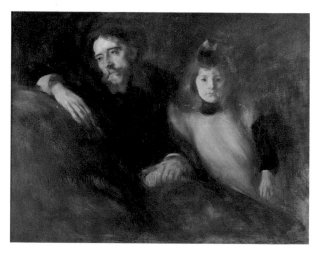

EUGÈNE-CARRIÈRE (1849–1906).
Alphonse Daudet and His Daughter, 1890. Oil on canvas,
35⅜ x 45⅝ in. (90 x 116 cm).

EUGÈNE CARRIÈRE (1849–1906).
Paul Verlaine, 1891. Oil on canvas, 24 x 20⅛ in.
(61 x 51 cm).

ARISTIDE MAILLOL (1861–1944).
Woman with Umbrella, n.d. Oil on canvas,
74¾ x 58⅝ in. (190 x 149 cm).

ODILON REDON (1840–1916).
Paul Gauguin, 1903–5. Oil on canvas,
26 x 21⅜ in. (66 x 54 cm).

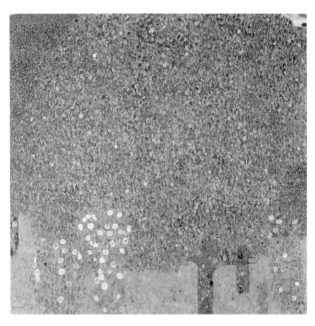

GUSTAV KLIMT (1862–1918).
Roses under the Trees, c. 1905. Oil on canvas,
43⅜ x 43⅜ in. (110 x 110 cm).

EDVARD MUNCH (1863–1944).
Summer Night at Asgarstrand, 1904. Oil on canvas,
39 x 40⅝ in. (99 x 103 cm).

ANDRÉ DERAIN (1880–1954).
Charing Cross Bridge, c. 1906. Oil on canvas,
31⅞ x 39⅜ in. (81 x 100 cm).

HENRI MATISSE (1869–1954).
Luxe, calme et volupté, 1904. Oil on canvas,
38⅝ x 46½ in. (98 x 118 cm).

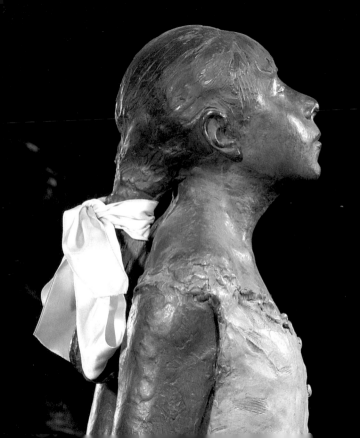

SCULPTURE

In his review of the 1846 Salon, Charles Baudelaire (who was inspired to write the poem *Le Masque* by Ernest Christophe's sculpture of the same title, page 228) wondered "why sculpture is boring." More costly to produce and often dependent on public commissions, sculpture has been slower to change than painting, even though all the major nineteenth-century movements have been represented in it, from Neoclassicism (Antonio Canova, for example, influenced students at the French Academy in Rome) to Romanticism (despite Théophile Gautier's declaration that "all sculpture is necessarily classical") and Realism (even though Jules Dalou's work lagged behind its pictorial antecedents by twenty years).

Some of the works shown here provoked scandals, including pieces by Auguste Clésinger and Edgar Degas, Auguste Rodin's *Balzac* (page 252), and Jean-Baptiste Carpeaux's *Dance* (page 231). The latter, like Charles Garnier's Opéra for which it was conceived, is a masterpiece of stylistic eclecticism. Such eclecticism imposed itself everywhere, from outdoor monuments to Salon pieces such as Paul Dubois's *Florentine Singer of the Fifteenth Century* (page 232). There was a related tendency to play with

diverse materials and techniques; Charles Cordier, like the sculptors of antique Rome, combined bronze and onyx in his *Arab in a Burnoose* (page 227).

Certain painters followed a path blazed by the painter-sculptor-draftsman Honoré Daumier as audacious innovators in sculptural art. Among them were Degas, whose extraordinary *Little Dancer Fourteen Years Old* (page 245) seems to lack only movement, and Paul Gauguin, who responded to the influence of "primitivism" by returning to direct cutting and polychromy, as in *Be Mysterious,* executed in Brittany in 1890 (page 247).

Synthetism, a style that evolved in the early 1900s, was in part directed against Rodin's genius at modeling and assembling. We see this reaction in the work of Aristide Maillol, whose *Mediterranean* (page 251) prompted André Gide to comment: "It is beautiful, it means nothing, it's a silent work." In work by Emile-Antoine Bourdelle this reaction against Rodin took the form of a new definition of sculpture in relation to architecture. Nonetheless, Rodin remains the great point of intersection between his century and ours. Without fear of narrative or eloquence, he brought together almost all of his sculptural creatures in *The Gates of Hell* (page 253), a state commission for a museum of decorative arts in Paris.

Honoré Daumier (1808–1879).
Portraits of Juste Milieu Celebrities: Charles Philipon, or
Toothless Laughter, 1831. Oil-glazed potter's clay,
6⅜ x 5¼ x 3⅞ in. (16 x 13 x 10 cm).

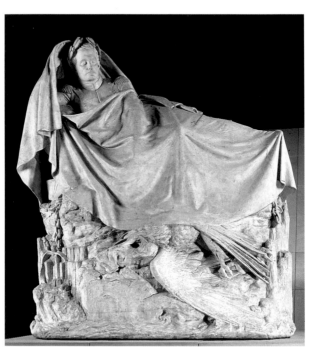

François Rude (1784–1855).
Napoleon Awakening to Immortality, 1842. Plaster model,
84⅝ x 76¾ x 37¾ in. (215 x 195 x 96 cm).

AUGUSTE PRÉAULT (1809–1879).
Virgil, 1853. Bronze medallion, 37⅜ x 33½ x 9⅛ in.
(95 x 85 x 23 cm).

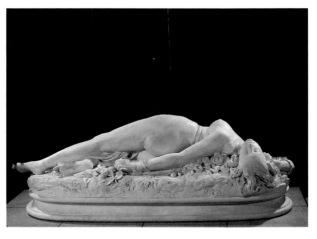

Auguste Clésinger (1814–1883).
Woman Bitten by a Snake, 1847. Marble, 22 x 70⅞ x 27⅝ in.
(56 x 180 x 70 cm).

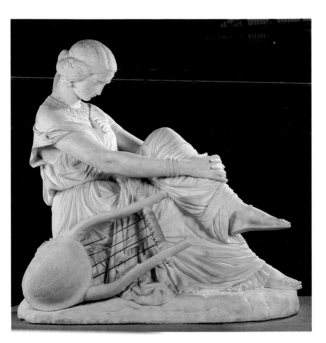

JAMES PRADIER (1790–1852).
Sappho, 1852. Marble, 46½ x 27⅝ x 47¼ in.
(118 x 70 x 120 cm).

ANTOINE-LOUIS BARYE (1796–1875).
War, 1855. Model, tinted plaster,
41⅜ x 24⅜ x 35¾ in. (105 x 62 x 91 cm).

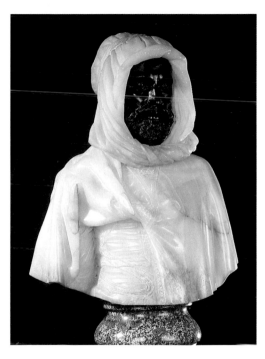

CHARLES CORDIER (1827–1905).
Arab in a Burnoose, 1857. Bronze and onyx,
16⅞ x 20⅞ x 15¾ in. (43 x 53 x 40 cm).

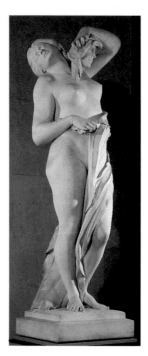

ERNEST CHRISTOPHE (1827–1892).
The Human Comedy, or *The Mask*, 1857–76. Marble,
96½ x 33½ x 28¾ in. (245 x 85 x 72 cm).

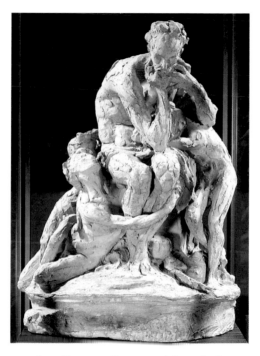

JEAN-BAPTISTE CARPEAUX (1827–1875).
Ugolino, 1860. Terra-cotta sketch, 22⅛ x 16⅛ x 11 in.
(56 x 41 x 28 cm).

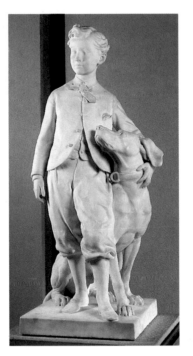

JEAN-BAPTISTE CARPEAUX (1827–1875).
The Prince Imperial and His Dog, Nero, 1865. Marble,
55⅛ x 25⅝ x 24 in. (140 x 65 x 61 cm).

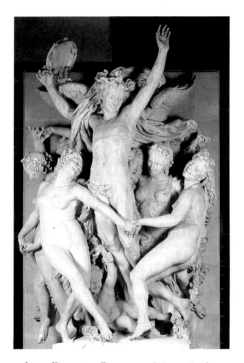

JEAN-BAPTISTE CARPEAUX (1827–1875).
The Dance, 1865–69. Stone,
13 ft. 8⅜ in. x 9 ft. 9⅝ in. x 4 ft. 8⅜ in. (4.2 x 2.98 x 1.45 m).

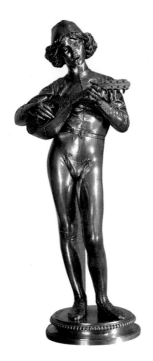

PAUL DUBOIS (1829–1905).
Florentine Singer of the Fifteenth Century, 1865–67.
Silvered bronze, 61 x 22¾ x 19⅝ in. (155 x 58 x 50 cm).

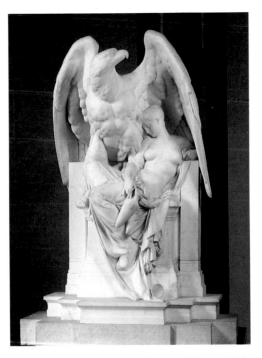

ALBERT–ERNEST CARRIER-BELLEUSE (1824–1887).
Sleeping Hebe, 1869. Marble, 81½ x 57½ x 33½ in.
(207 x 146 x 85 cm).

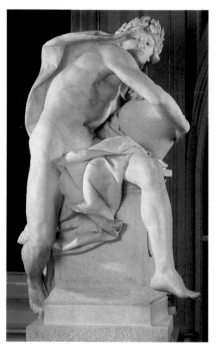

CHARLES-RENÉ DE SAINT-MARCEAUX (1845–1915).
Genius Protecting the Secret of the Tomb, 1879. Marble,
66½ x 37⅜ x 46⅞ in. (168 x 95 x 119 cm).

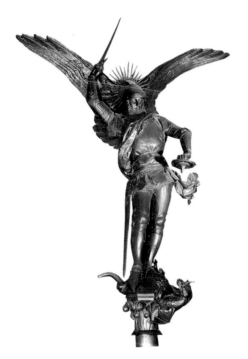

EMMANUEL FREMIET (1824–1910).
Saint Michael, 1879–97. Hammered copper,
20 ft. 2⅞ in. x 8 ft. 6⅜ in. x 4 ft. (6.17 x 2.6 x 1.2 m).

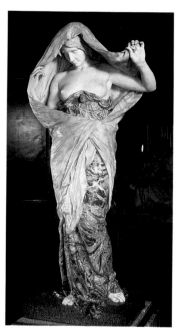

LOUIS-ERNEST BARRIAS (1841–1905).
Nature Revealed to Science, 1899. Polychrome Algerian
marbles and onyx, gray granite, malachite, and lapis lazuli,
78⅝ x 33½ x 21⅝ in. (200 x 85 x 55 cm).

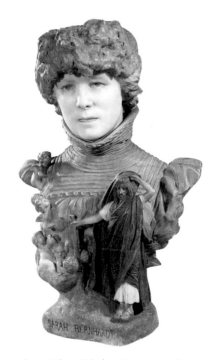

JEAN-LÉON GÉRÔME (1824–1904).
Sarah Bernhardt, c. 1895. Tinted marble, 27¼ x 16⅛ x 11⅜ in.
(69 x 41 x 29 cm).

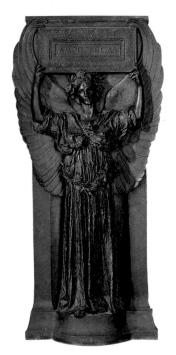

AUGUSTUS SAINT-GAUDENS (1848–1907).
Charity, 1885. Bronze high relief, 10⅞ x 50 x 11¾ in.
(264 x 127 x 30 cm).

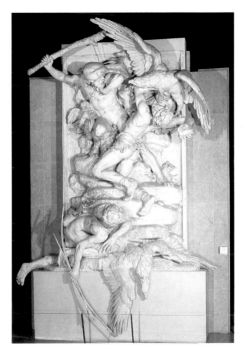

JULES COUTAN (1848–1939).
The Eagle Hunters, 1900. Plaster high relief,
17½ ft. x 10 ft. x 3 ft. 9¾ in. (5.35 x 3.05 x 1.2 m).

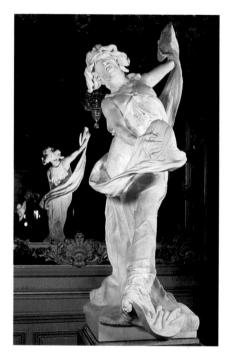

VICTOR SÉGOFFIN (1867–1925).
War Dance, or *Sacred Dance*, 1905. Marble,
98⅜ x 55⅛ x 31½ in. (250 x 140 x 80 cm).

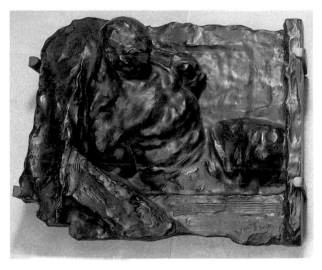

BERNHARDT HOETGER (1874–1949).
The Human Machine, 1902. Bronze relief,
17⅜ x 14⅝ x 7⅛ in. (44 x 37 x 18 cm).

JULES DALOU (1838–1902).
The Peasant, 1899–1902. Bronze, 77⅝ x 27⅝ x 26¾ in.
(197 x 70 x 68 cm).

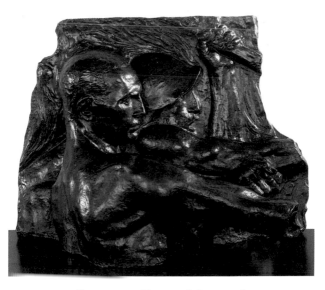

CONSTANTIN MEUNIER (1831–1905).
Industry, 1892–96. Bronze high relief, 26¾ x 35¾ x 14¼ in.
(68 x 91 x 36 cm).

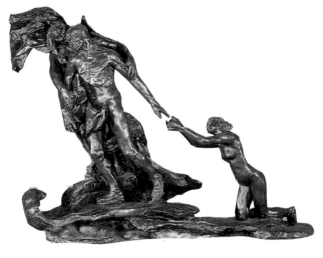

CAMILLE CLAUDEL (1864–1943).
Maturity, 1893–1903. Bronze, 44⅞ x 64¼ x 28⅜ in.
(114 x 163 x 72 cm).

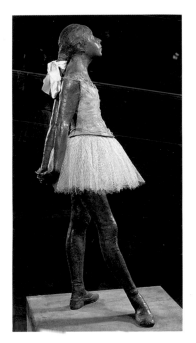

EDGAR DEGAS (1834–1917).
Little Dancer Fourteen Years Old, 1881. Patinated bronze,
cotton skirt, and pink satin ribbon, 38⅝ x 13¾ x 9½ in.
(98 x 35 x 24 cm).

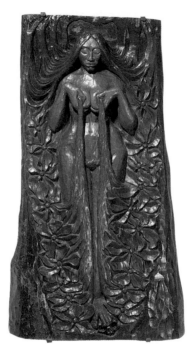

GEORGES LACOMBE (1868–1916).
Isis, 1895. Partially polychromed mahogany bas-relief,
43⅝ x 24⅜ x 3⅞ in. (111 x 62 x 10 cm).

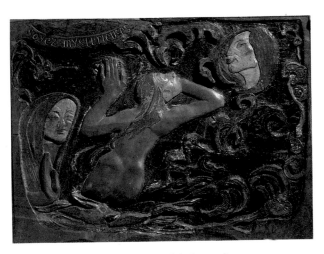

PAUL GAUGUIN (1848–1903).
Be Mysterious, 1890. Polychromed limewood bas-relief,
28⅝ x 37⅜ x 2 in. (73 x 95 x 5 cm).

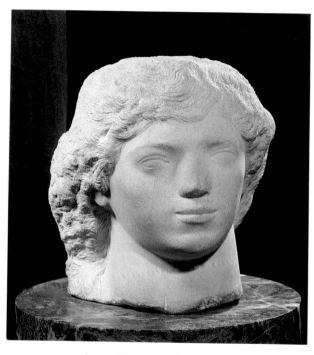

JOSEPH BERNARD (1866–1931).
Effort toward Nature, 1907. Stone, 12⅝ x 11⅜ x 12¼ in.
(32 x 29 x 31 cm).

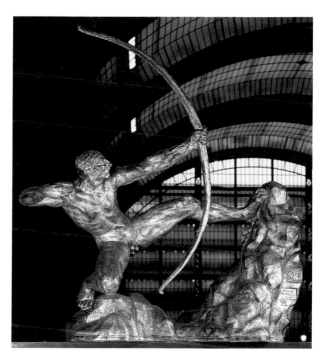

EMILE-ANTOINE BOURDELLE (1861–1929).
Hercules the Bowman, 1909. Gilt bronze, 97⅝ x 97¼ x 43⅜ in.
(248 x 247 x 123 cm).

PIERRE-AUGUSTE RENOIR (1841–1919).
Madame Renoir, 1916. Polychromed cement,
32⅜ x 20⅞ x 13⅜ in. (82 x 53 x 34 cm).

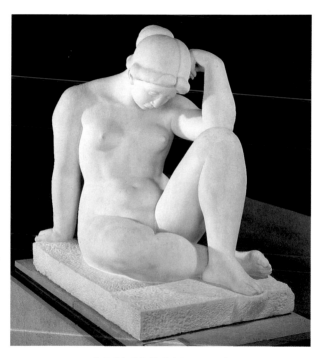

Aristide Maillol (1861–1944).
Mediterranean, or *Thought*, 1905–23. Marble,
32⅜ x 20⅞ x 13⅜ in. (110 x 117 x 68 cm).

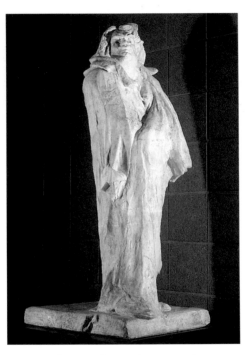

AUGUSTE RODIN (1840–1917).
Balzac, 1898. Plaster, 108⅜ x 47⅝ x 52 in.
(275 x 121 x 132 cm).

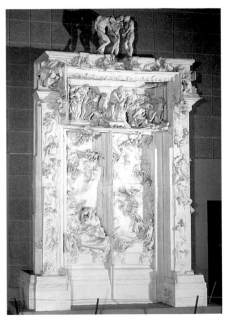

Auguste Rodin (1840–1917).
The Gates of Hell, 1880–1917. Plaster high relief,
17 ft. x 13 ft. 1½ in. x 3 ft. 1 in. (5.2 x 4 x .94 m).
Surmounted by *The Shades,*
38⅝ x 35⅜ x 19⅝ in. (98 x 90 x 50 cm).

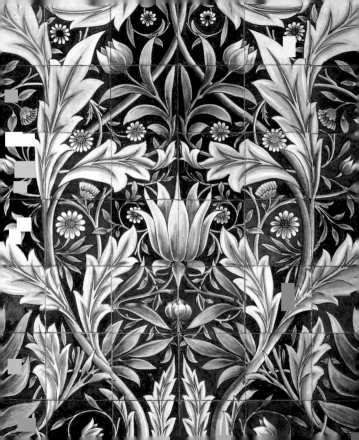

DECORATIVE ARTS

"Our century is formless . . . ," said Alfred de Musset. "We have a little of every century except our own." The term *eclecticism* applies even more to the decorative arts than to painting and sculpture. Even Art Nouveau did not make a total break with eclecticism; for example, the iconography of Emile Gallé's *Hand with Seaweed and Shells* (page 279), his last creation in glass, took its inspiration from various religious sources.

The central idea of eclecticism in the decorative arts is the marriage of art (the beautiful) and industry (the functional). The nineteenth century continued to straddle two sets of ideas, recognizing the necessity of mass production but remaining dependent on artisanal techniques. It continued to dote on the unique piece, on which artists and artisans would collaborate (from Alphonse-Ernest Carrier-Belleuse and Claudius Popelin to Louis Comfort Tiffany and Henri de Toulouse-Lautrec), particularly for the periodic world fairs. The era was marked by two major inventions—mechanical reduction and Jean Christofle's electroplating— but decorative objects remained expensive, and many of them were destined for a newly wealthy clientele that was sometimes lacking in traditions of taste.

Stylistically, eclecticism found sources in everything from ancient Egypt to the eighteenth century. Charles-Jean Avisseau copied Bernard Palissy, while Philippe-Joseph Brocard imitated thirteenth- and fourteenth-century Syro-Egyptian glass. From 1878 to 1889 Japonism paved the way for Art Nouveau.

The idea that structure was inseparable from decoration, that art should aim for a unified totality, shaped the precepts of William Morris and the Arts and Crafts movement in England. Four tendencies can be distinguished in Art Nouveau: abstract and dynamic (Franco-Belgian), organic and vegetal (in Nancy, France), linear and flat (Charles Rennie Mackintosh in Glasgow), and geometric and constructive (in Germany and Austria). The last was associated with the Secession, organized in Vienna in 1897, and with the founding by Josef Hoffmann and Koloman Moser of the Wiener Werkstätte in 1903.

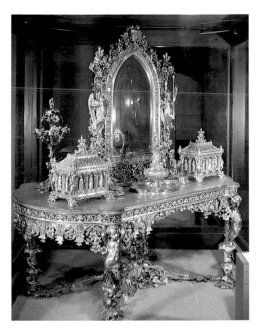

FRANÇOIS-DÉSIRÉ FROMENT-MEURICE (1802–1855) with
architect JACQUES-FÉLIX DUBAN and sculptors JEAN-JACQUES
FEUCHÈRE and GEOFFROY-DECHAUME. *Dressing Table,* 1847–51.
Partially gilt silver, gilt and silvered bronze, engraved iron,
and enamel, height: 86⅝ in. (210 cm).

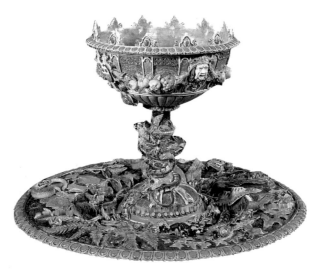

CHARLES-JEAN AVISSEAU (1796–1861) and OCTAVE GUILLAUME
DE ROCHEBRUNE (1824–1900). *Goblet and Bowl,* 1855.
Polychromed porcelain, sculpted and inlaid; goblet: 13¾ x
10¼ in. (34 x 26 cm); bowl: 3¼ x 20⅛ in. (8 x 51 cm).

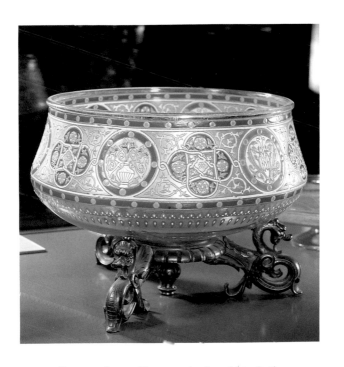

PHILIPPE-JOSEPH BROCARD (active 1865–1896).
Bowl, 1871. Blown glass, enameled and gilt, with original
blackened wood base, 7⅞ x 15⅜ in. (20 x 39 cm).

CHARLES–GUILLAUME DIEHL (1811–c. 1885?) with JEAN
BRANDELY and EMMANUEL FREMIET. *Medal Cabinet,* 1867.
Cedar, ebony, ivory, silver-plated bronze, and copper,
93⅝ x 59⅜ x 23⅝ in. (238 x 151 x 60 cm).

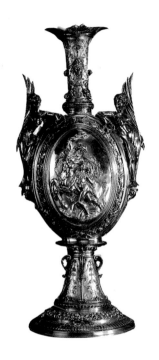

CHRISTOFLE & CIE, with MATHURIN MOREAU.
Vase Depicting the Education of Achilles, 1867.
Partially gilt silver, 29½ x 10¼ x 5⅛ in. (75 x 26 x 13 cm).

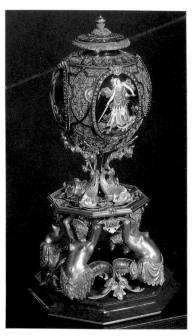

PROSPER-EUGÈNE FONTENAY (1823–1887) with
EUGÈNE RICHET. *Incense Burner,* c. 1878. Gold, translucent
enamel, and enamel paint in relief with diamonds and
lapis lazuli, 8⅜ x 4⅜ in. (21 x 11 cm).

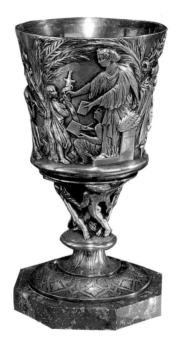

ALBERT–ERNEST CARRIER-BELLEUSE (1824–1887) with
CLAUDIUS MARIOTON and TAXILE DOAT. *Goblet*, 1886.
Porphyry, silver, and porcelain, 17⅜ x 11 x 10⅝ in.
(44 x 28 x 27 cm).

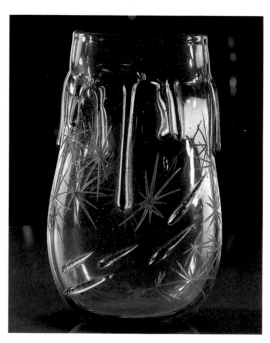

FRANÇOIS-EUGÈNE ROUSSEAU (1827–1890).
Vase (Model with "Tears"), 1875–78. Tinted, engraved,
painted, enameled, and gilt glass with overlays,
9¾ x 9⅛ x 2 in. (25 x 23 x 5 cm).

EMILE GALLÉ (1846–1904).
Ornamental Plate, c. 1878. Polychromed faience decorated with
enamels and gold highlights, diameter: 22¾ in. (58 cm).

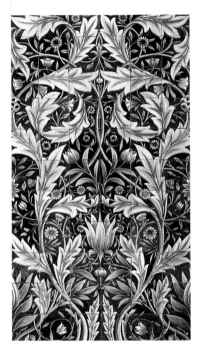

WILLIAM MORRIS (1834–1896) with WILLIAM DE MORGAN.
Panel, c. 1876–77. 66 tiles of polychromed faience,
64¼ x 35⅜ in. (163 x 90 cm).

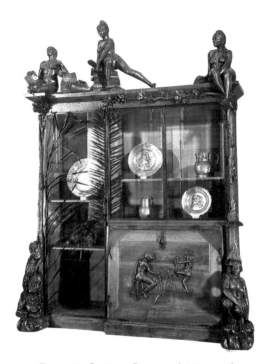

François-Rupert Carabin (1862–1932).
Bookcase, 1890. Walnut and wrought iron,
114¼ x 84⅝ x 32⅝ in. (290 x 215 x 83 cm).

CHRISTOPHER DRESSER (1834–1904) for Hukin and Heath, Birmingham, England. *Soup Tureen,* 1880. Silver plate and ebony, 8⅜ x 12¼ x 9⅛ in. (21 x 31 x 23 cm).

CLÉMENT MASSIER (1845–1917).
Ewer, c. 1893–94. Faience with metallic luster,
height: 33½ in. (85 cm).

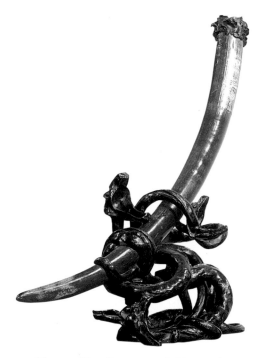

Léopold Van Strydonck (1861–1937).
The Struggle Between Good and Evil, 1897. Ivory and bronze,
29⅞ x 27⅝ x 13¾ in. (76 x 70 x 35 cm).

LOUIS COMFORT TIFFANY (1848–1933)
after HENRI DE TOULOUSE-LAUTREC (1864–1901).
At the Nouveau Cirque, 1895. Glass and cabochons,
47¼ x 33½ in. (120 x 85 cm).

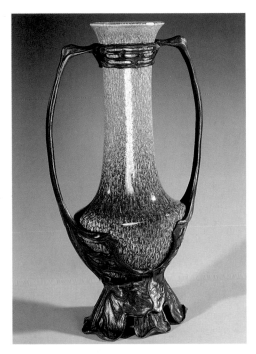

OTTO ECKMANN (1865–1902) for the Königliche Porzellan Manufaktur. *Vase,* c. 1897–99. Porcelain with patinated bronze mount, 20⅛ x 11⅜ x 6⅜ in. (51 x 29 x 16 cm).

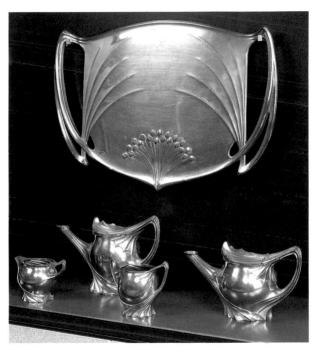

PAUL FOLLOT (1877–1941) for Christofle & Cie.
Tea Service, c. 1903. Silvered metal, length: 24 in. (61 cm).

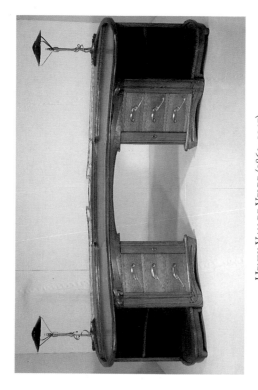

HENRY VAN DE VELDE (1863–1957).
Writing Desk, 1893–99. Oak, gilt bronze, copper, and leather,
50⅜ x 105½ x 48 in. (128 x 268 x 122 cm).

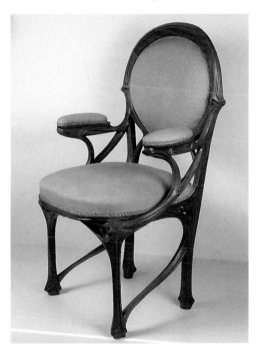

HECTOR GUIMARD (1867–1942).
Armchair, 1898–99. Walnut, 45⅝ x 26¾ x 20½ in.
(116 x 68 x 52 cm).

CARLO BUGATTI (1856–1940).
Chair, c. 1902. Mahogany, parchment, and pale wood
filleting, 39¼ x 14⅝ x 20⅞ in. (97 x 37 x 53 cm).

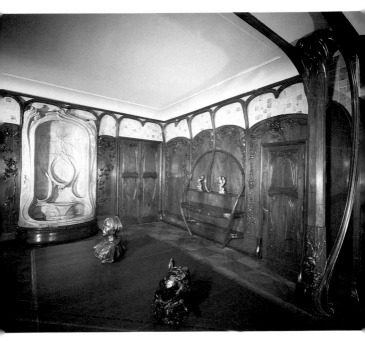

ALEXANDRE-LOUIS-MARIE CHARPENTIER (1856–1909)
with ALEXANDRE BIGOT. *Dining Room,* c. 1901.
Mahogany, oak, poplar, gilt bronze, and enameled stoneware,
11 ft. 4 in. x 34 ft. 7 in. x 20 ft. 4 in. (3.46 x 10.55 x 6.21 m).

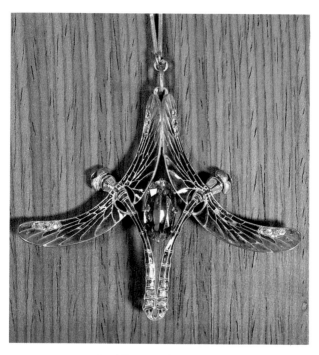

RENÉ LALIQUE (1860–1945).
Pendant, 1903–5. Gold, translucent cloisonné enamel,
brilliants, and aquamarine, length: 2⅜ in. (6 cm).

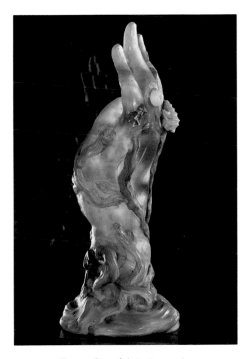

EMILE GALLÉ (1846–1904).
Hand with Seaweed and Shells, 1904. Engraved crystal with
additions and applications, 13 x 5⅛ in. (33 x 13 cm).

LOUIS MAJORELLE (1859–1926).
"Orchid" Desk, c. 1903–5. Mahogany, gilt bronze, and
embossed leather, 37⅜ x 66⅞ x 27⅝ in. (95 x 170 x 70 cm).

KOLOMAN MOSER (1868–1918) for the Wiener Werkstätte.
Music Cupboard, c. 1904. Oak treated with white lead
and varnished in black, gilded wood, silver-plated chased
metal, white metal, and glass, 78⅜ x 78¾ x 25⅝ in.
(199 x 200 x 65 cm).

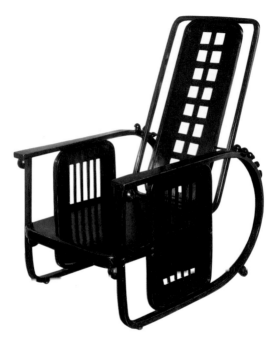

JOSEF HOFFMANN (1870–1956) for Jacob & Josef Kohn.
Reclining Armchair, c. 1908. Laminated, bent, and
perforated beechwood, with mahogany varnish and latten,
43⅜ x 24⅜ x 32⅜ in. (110 x 62 x 82 cm).

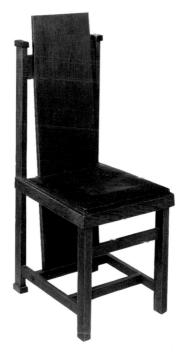

FRANK LLOYD WRIGHT (1867–1959).
Chair, c. 1908. Oak and leather, 49¼ x 17⅝ x 20⅛ in.
(125 x 45 x 51 cm).

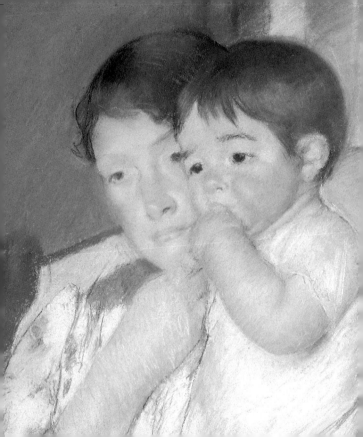

PASTELS

Pastels, which had experienced a particular vogue in the course of the eighteenth century, continued in the nineteenth century to be used by artists of every current, from Eugène Delacroix on. A somewhat unpredictable powder, pastel allows for a maximum of experimentation, enabling artists to express the instantaneity of observation as well as visionary allusion.

The works in this chapter range from the audacity of Jean-François Millet's thick crosshatching of pure color to Edouard Manet's increasingly fresh portraits from 1873 on. Edgar Degas appears here as the most consummate draftsman. Though beset by advancing age and increasingly blurred vision, he managed to free himself from all restraints. His technical inventiveness led him to wet his chalk in oil mixtures or to mix pastel and distemper; he practiced stump drawing, left swatches of blank paper, and experimented with monotypes and lithography. In addition to employing these mixed techniques, he piled up multiple layers almost obsessively, exhibiting a taste for variations on a theme, for unprecedented choices in framing his images, for the art of the close-up, as Millet had done. One example of these tendencies is the diagonal

that runs through *The Star* (page 289) and the artificial light from below; another is the single plane into which everything is reduced, as if observed "through a keyhole," in *The Tub* (page 290). The boundaries between painting and drawing are abolished.

For the Symbolists, pastel served to communicate the implacable precision of a dream, in which one color often predominates (see *Nocturne at the Royal Park, Brussels,* by William Degouve de Nuncques, page 294), and deliberately esoteric themes (as in Lucien Lévy-Dhurmer's *Medusa,* page 295). The pastels of Odilon Redon, who began using this technique only after passing through an ascetic black period, feature colors of infinite subtlety.

JEAN-FRANÇOIS MILLET (1814–1875).
Bouquet of Daisies, 1871–74. Pastel on beige paper mounted
on canvas, 27⅝ x 32⅝ in. (70 x 83 cm).

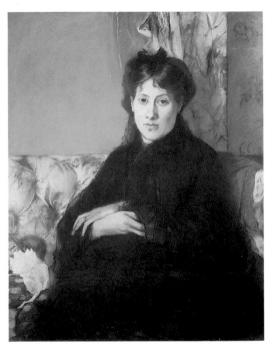

BERTHE MORISOT (1841–1895).
Portrait of Madame Edma Pontillon, née Edma Morisot, Sister of the Artist, 1871. Pastel on paper, 31½ x 25¼ in. (80 x 64 cm).

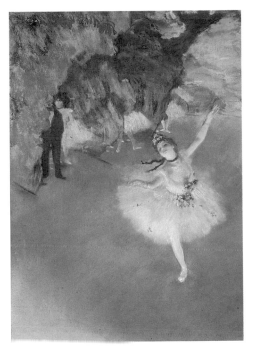

EDGAR DEGAS (1834–1917).
The Star, or *Dancer on Stage,* c. 1876–77. Pastel on monotype
on paper, 23⅝ x 17⅝ in. (60 x 44 cm).

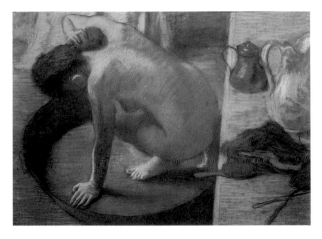

Edgar Degas (1834–1917).
The Tub, 1886. Pastel on cardboard, 23⅝ x 32⅝ in.
(60 x 83 cm).

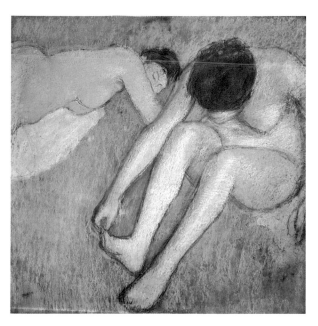

EDGAR DEGAS (1834–1917).
Two Bathers on the Grass, 1886–90. Pastel on brown paper,
27⅝ x 27⅝ in. (70 x 70 cm).

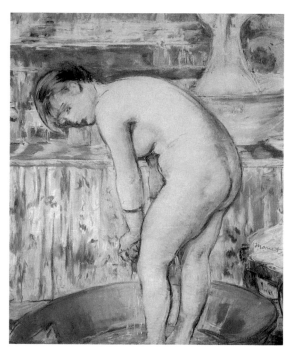

EDOUARD MANET (1832–1883).
Woman in a Tub, 1878–79. Pastel on canvas, 21⅜ x 17⅝ in.
(54 x 45 cm).

EDOUARD MANET (1832–1883).
Irma Brunner (Woman in a Black Hat), c. 1880–82. Pastel on
canvas, 20⅞ x 17⅜ in. (53 x 44 cm).

WILLIAM DEGOUVE DE NUNCQUES (1867–1935).
Nocturne at the Royal Park, Brussels, 1897. Pastel on paper,
25⅝ x 19⅝ in. (65 x 50 cm).

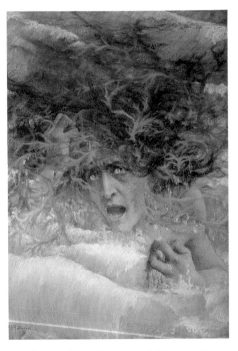

LUCIEN LÉVY-DHURMER (1865–1953).
Medusa, or *The Angry Wave,* 1897. Pastel and charcoal on beige
paper mounted on cardboard, 23¼ x 15¾ in. (59 x 40 cm).

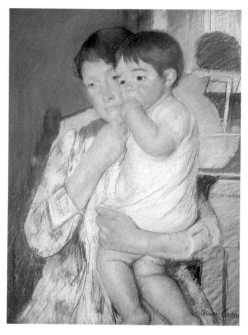

MARY CASSATT (1844–1926).
Mother and Child Against a Green Background, or *Maternity*,
1897. Pastel on beige paper mounted on canvas,
21⅝ x 18⅛ in. (55 x 46 cm).

ODILON REDON (1840–1916).
Buddha, c. 1906–7. Pastel on beige paper, 35⅜ x 28⅝ in.
(90 x 73 cm).

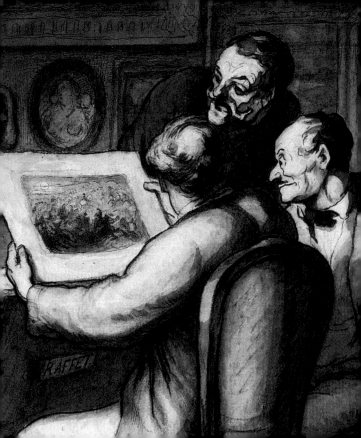

DRAWINGS AND WATERCOLORS

For Jean-Auguste-Dominique Ingres, drawing was "the probity of art"; at the other end of the century Pierre Bonnard responded by asserting that "drawing is sensation; color is reasoning."

Nineteenth-century draftsmen loved combining elements, pushing the possibilities of the medium to the extreme. Working on paper, a Jean-François Millet or a Gustave Moreau could be freer than in painting on canvas. The instruments employed might be pen, brush, metalpoint, charcoal, red chalk (Pierre-Auguste Renoir, Aristide Maillol), ink (sometimes as a wash), watercolor (sometimes enhanced with touches of gouache, as in Eugène Boudin and Edouard Manet), pastel, or colored pencils (Henri de Toulouse-Lautrec). In the case of the pencil, the old black chalk was put to rest and, at the time of the Revolution, the Conté pencil was created, which later inspired Camille Corot and Edgar Degas. Later still, a softer pencil was used, which lent itself to a more monumental style in the work of Honoré Daumier and Jean-Baptiste Carpeaux.

Aesthetic elements seem to become liberated in drawing. The cursive line of the caricature predominates

in the work of Honoré Daumier or Lautrec; a mixture of writing and drawing characterizes Paul Gauguin's *Noa-Noa* album (page 317), which calls to mind Eugène Delacroix's notebooks from his travels in Morocco. Renouncing color, Georges Seurat preferred a scumble of soft black Conté pencil on rough-grained white paper, which he left showing through; anecdote and reality have disappeared, and all that remains is the allusion to striking, isolated details, as in *The Black Knot* (page 313).

Watercolor, which experienced a revival under English influence, allowed Paul Cézanne to create a prism of transparencies and superimpositions, yielding images that fragment into multiple facets and eliminate linear, finite perspective. Strangely, the initial pencil outline, which he never followed, is left visible. Finally, in the drawings of Piet Mondrian, the final stage of a nineteenth-century Dutch tradition coexists with the birth of a new angular space.

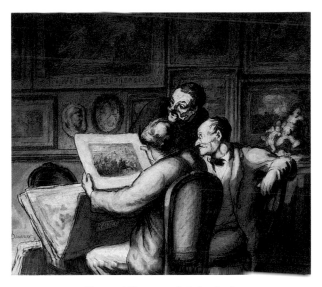

HONORÉ DAUMIER (1808–1879).
The Print Collectors, n.d. Watercolor, gouache, pencil, and
pen and india ink on paper, 10¼ x 12¼ in. (26 x 31 cm).

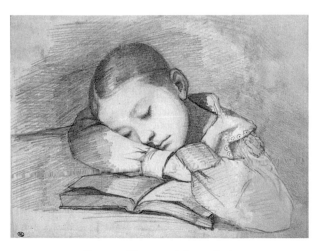

GUSTAVE COURBET (1819–1877).
Portrait of Juliette Courbet as a Sleeping Child, c. 1841.
Graphite on paper, 7⅞ x 10¼ in. (20 x 26 cm).

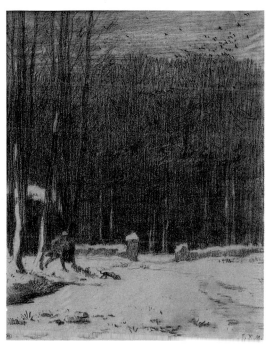

JEAN-FRANÇOIS MILLET (1814–1875).
The Barn Door in the Snow, 1853. Pencil on paper,
11 x 8⅝ in. (28 x 22 cm).

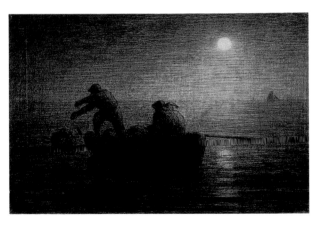

JEAN-FRANÇOIS MILLET (1814–1875).
Fishermen, n.d. Pencil on paper, 12⅝ x 19⅜ in.
(32 x 49 cm).

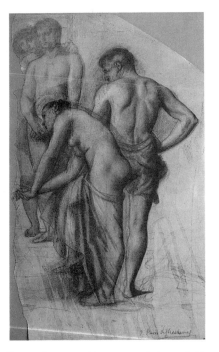

PIERRE PUVIS DE CHAVANNES (1824–1898).
Study of Four Figures for "Repose," 1863. Sanguine, pencil, and
white gouache on cream paper, 28⅝ x 16⅞ in. (73 x 43 cm).

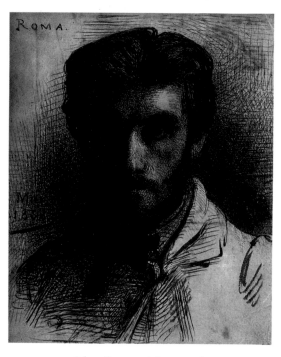

LÉON BONNAT (1833–1922).
Self-Portrait, 1858. Pen and india ink and wash on paper,
7⅛ x 5½ in. (18 x 14 cm).

EDGAR DEGAS (1834–1917).
Portrait of Manet, c. 1860. Graphite and india ink wash
on paper, 13¾ x 7¾ in. (35 x 20 cm).

EDOUARD MANET (1832–1883).
Christ with Angels, 1864. Graphite, watercolor, gouache,
and pen and india ink on paper, 12⅝ x 10⅝ in. (32 x 27 cm).

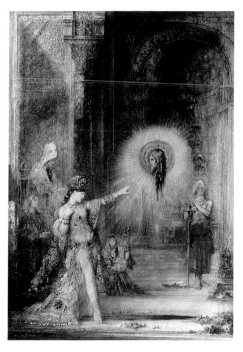

GUSTAVE MOREAU (1826–1898).
The Apparition, 1876. Watercolor on paper, 41⅝ x 28⅜ in.
(106 x 72 cm).

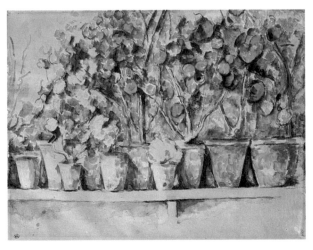

PAUL CÉZANNE (1839–1906).
The Pots of Flowers, c. 1885. Graphite and watercolor on
beige paper, 9⅛ x 11¾ in. (23 x 30 cm).

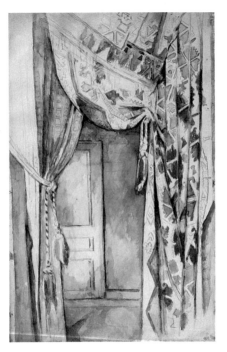

PAUL CÉZANNE (1839–1906).
The Curtains, c. 1885. Watercolor on paper,
19⅜ x 11¾ in. (49 x 30 cm).

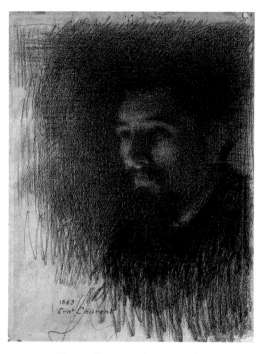

ERNEST LAURENT (1859–1929).
Portrait of the Painter Georges Seurat, 1883. Charcoal on paper,
15⅜ x 11⅜ in. (39 x 29 cm).

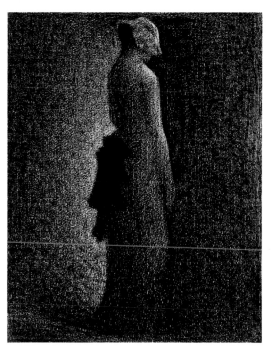

GEORGES SEURAT (1859–1891).
The Black Knot, c. 1882. Conté crayon on paper,
12¼ x 9⅛ in. (31 x 23 cm).

RODOLPHE BRESDIN (1825–1885).
The Rocks, 1884. Gray wash and white gouache on paper,
19⅜ x 15⅜ in. (49 x 39 cm).

VINCENT VAN GOGH (1853–1890).
Père Eloi's Farm, 1890. Graphite with pen and brown ink
on paper, 18⅞ x 24 in. (48 x 61 cm).

HENRI DE TOULOUSE-LAUTREC (1864–1901).
Two Women Waltzing, c. 1894. Charcoal and oil on tracing
paper mounted on cardboard, 22¾ x 15⅝ in. (58 x 40 cm).

PAUL GAUGUIN (1848–1903).
Noa Noa Album, folio 75, 1893–97. Watercolor, pen and
black ink, and woodcut with watercolor on paper,
11¾ x 11 in. (30 x 28 cm).

PIET MONDRIAN (1872–1944).
Going Fishing (Zuider Zee), c. 1900. Watercolor and
charcoal on paper, 24⅜ x 39⅜ in. (62 x 100 cm).

PIERRE BONNARD (1867–1947).
Fruit, c. 1930. Watercolor and gouache with traces of
pencil on paper, 14⅝ x 13 in. (37 x 33 cm).

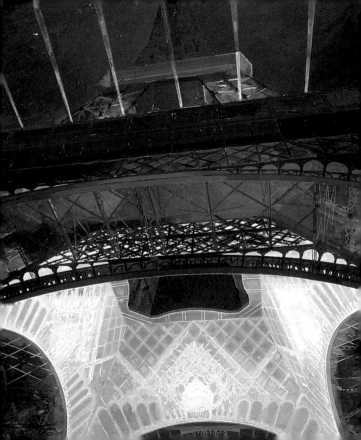

ARCHITECTURE

There have been notable architectural drawings from the Renaissance on, but in the nineteenth century their pedagogical value became particularly valued. In the 1890s a plan was announced to create a "gallery of architectural drawings" at the Louvre. The Musée d'Orsay is in some sense its heir, but with a broader and different sort of ambition than just to create a collection of drawings. What counts more than the individual drawing is the whole of a bequest or a collection, as in the Eiffel bequest, which gathers all the materials that might contribute to a knowledge of the architect.

The Musée d'Orsay also houses picturesque drawings made by architects, travel sketches, finished landscapes, projects for monuments, and presentation drawings prepared with an exhibition or Salon in mind (see, for example, Adolphe Alphand's plan for the never-realized drilling of an artesian well in Passy, France, page 325). Indeed, exceptional creators such as Eugène Viollet-le-Duc attempted all genres, including decorative-art projects and illustrations.

Architectural drawings played a key role in academic competitions and the Prix de Rome; from the Villa

Medici, each month the winner of the prize had to send the Institute surveys of antique monuments. Such academic examinations were divided into various types, including "restoration," which allowed for more or less imaginary interpretations, as in Gabriel-Auguste Ancelet's reconstruction of a portico at Pompeii (page 323).

The end of the nineteenth century saw the triumph of the engineer over the traditional architect—a fact symbolized by the functionalist beauty of the Eiffel Tower. Henri Toussaint's rendering of his 1900 project for decorating the tower (page 333) makes it clear that architectural drawing can at times assume the aspect of an ideal, utopian vision, while maintaining the beauty of a technical art.

GABRIEL-AUGUSTE ANCELET (1829–1895).
Reconstruction of a Decoration on the Portico of Macellum, Pompeii,
1853. Pencil, pen and black ink, india ink wash, watercolor,
and gouache on paper, 18½ x 11 in. (47 x 28 cm).

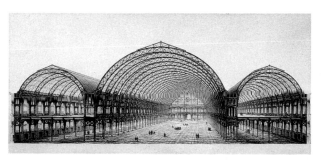

MAX BERTHELIN (1811–1877).
The Palace of Industry, Exposition Universelle of 1855:
Transverse Section, 1854. Pen and black ink with watercolor
on paper, 13 x 26⅝ in. (33 x 67 cm).

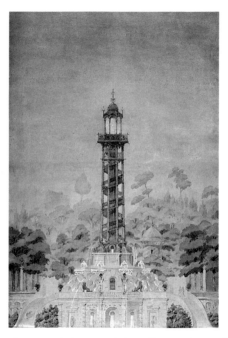

ADOLPHE ALPHAND (1817–1891), JEAN DARCEL (1823–?), and
EMILE REIBER (1826–1893). *Project for the Iron Tower for the
Passy Artesian Well,* 1857. Watercolor with white gouache
highlights on paper, 38⅝ x 23⅝ in. (98 x 60 cm).

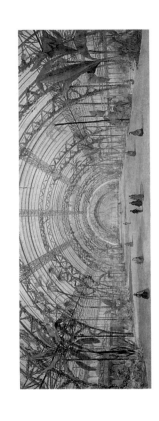

OWEN JONES (1809–1874).
Project for the Interior of a Crystal Palace, Saint-Cloud, France, c. 1860–62.
Watercolor, pencil, and colored pencil on paper,
17⅝ x 47¼ in. (45 x 120 cm).

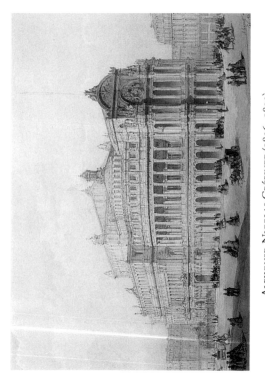

ALPHONSE–NICOLAS CRÉPINET (1826–1892).
Project for the New Paris Opéra: Perspective View, 1861. Graphite and watercolor on paper, 19⅝ x 26¾ in. (50 x 68 cm).

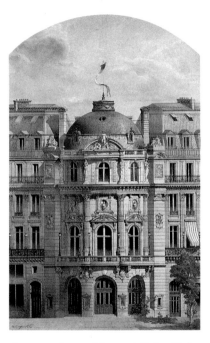

AUGUSTE-JOSEPH MAGNE (1816–1885).
Vaudeville Theater: Elevation of the Principal Facade, 1870.
Graphite, gray ink wash, watercolor, pen and black ink with
gouache and gold on paper, 31⅞ x 19⅝ in. (81 x 50 cm).

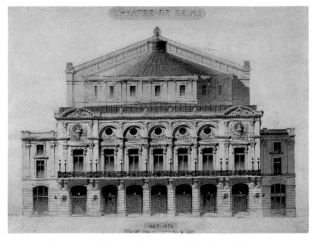

ALPHONSE GOSSET (1835–1914). *Rheims Theater:*
Elevation of the Principal Facade, 1867–73. Pen and black ink,
watercolor, and white gouache highlights on paper,
29½ x 35⅜ in. (75 x 90 cm).

HENRI-PAUL NÉNOT (1853–1934).
Project for a Monument to Gambetta on the Place de la Concorde, Paris, 1884.
Watercolor on paper, 11 x 27¼ in. (28 x 69 cm).

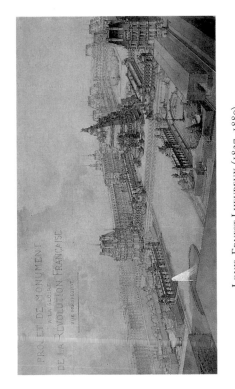

LOUIS-ERNEST LHEUREUX (1827–1880).
Monument to the Glory of the French Revolution, Bird's-Eye View, c. 1886–89.
Pencil, pen and black ink, gray wash, watercolor, and gold on paper,
18⅞ x 33⅞ in. (48 x 36 cm).

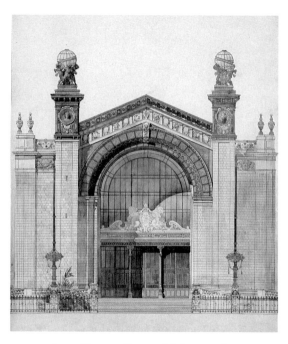

JEAN-CAMILLE FORMIGÉ (1845–1926).
*Palace of Fine Arts on the Champ de Mars, Exposition Universelle
of 1889: Elevation of Central Entry,* n.d. Graphite, pen and black
ink, and watercolor on paper, 40¼ x 25⅝ in. (102 x 65 cm).

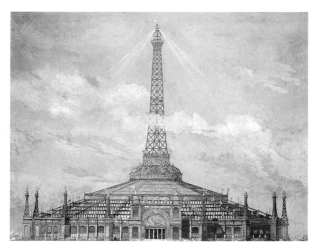

HENRI TOUSSAINT (1849–1911).
*Project for the Eiffel Tower, Exposition Universelle of 1900:
Elevation,* n.d. Gouache on paper, 35⅜ x 44⅞ in.
(90 x 114 cm).

ANDRÉ GRANET (1881–1974).
*Project for the Lighting of the Eiffel Tower for the
Exposition Universelle of 1937,* n.d. Gouache on paper,
32⅜ x 49¼ in. (82 x 125 cm).

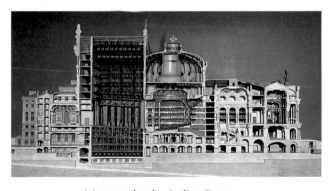

Maquette by the Atelier, Rome,
under the direction of Richard Peduzzi.
The Opéra: Maquette of a Longitudinal Section, 1982–86.

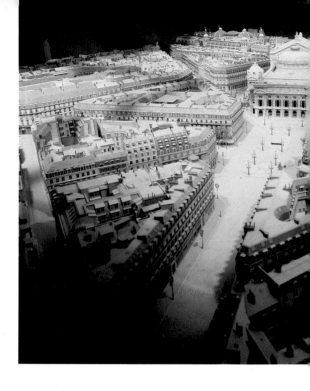

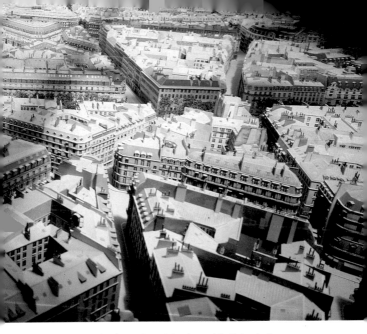

Maquette by Rémy Munier with Eric de Leusse.
Maquette of the Opéra District in 1914.

PHOTOGRAPHY

"Personally," said the photographer Gustave Le Gray, "I am hoping that instead of falling into the domain of industry and commerce, photography will enter into that of art. That is its true and only place." After some debate photography, which had initially been exhibited with scientific and industrial products, was included in the Salon, beginning in 1859.

Photography offered new ideas about the potential of the multiple and about the relationship between art and industry. Skill counted for less than in the other highly formalized arts, and many artists and writers became amateur photographers, including Edgar Degas, Pierre Bonnard, Victor Hugo, and Lewis Carroll. Sometimes even failed attempts can be strangely beautiful, as in Nadar's various portraits of Charles Baudelaire (opposite and page 347). By offering a new vision of reality, photography automatically presented new possibilities, and if there is one notion that is suspect in photography, it is that of objective realism. To give his *Marine* (page 349) its cosmic, timeless quality, Le Gray used two different negatives, one for the sea and one for the sky.

The true invention of photography dates to 1839

and the efforts of Jacques-Louis-Mandé Daguerre, who devised the daguerreotype (a single print on copper—the image is reversed and there is no negative). Next came William Henry Fox Talbot's calotype, founded on the principle of the paper negative. The 1860s saw the industrialization of the medium with extremely rapid technical progress. Painting and photography maintained a two-way dialogue at this time; on the one hand Degas and Marcel Duchamp were benefiting from the research into movement made possible by the chronophotography of Etienne-Jules Marey and Eadweard Muybridge; on the other hand, photographic Pictorialism was promoting a return to aesthetic preoccupations characteristic of painting in the 1850s.

The lyricism of the English school of photography is particularly apparent in the close-up studies by Julia Margaret Cameron, which in about 1870 foretold the Pictorialists. Among the self-proclaimed Pictorialists, who often specialized in soft-focus imagery, should be mentioned Alfred Stieglitz, Edward Steichen, and Clarence White. And on the margins of Pictorialism are major but unclassifiable artists, such as Eugène Atget, who was later much beloved by the Surrealists.

LOUIS-ADOLPHE HUMBERT DE MOLARD (1800–1874).
Louis Dodier (Humbert de Molard's butler) as a Prisoner, 1847.
Daguerreotype, 4½ x 6⅛ in. (11.5 x 15.5 cm).

BARON JEAN-BAPTISTE-LOUIS GROS (1793–1870).
The Parthenon Frieze, Athens, 1850. Daguerreotype,
4⅜ x 5⅝ in. (11 x 14.5 cm).

WILLIAM HENRY FOX TALBOT (1800–1877).
Porcelain Objects on Shelves, from *The Pencil of Nature,* 1844.
Talbotype on garnet-colored paper, 5½ x 7⅛ in.
(13.9 x 18 cm).

ANONYMOUS GERMAN PHOTOGRAPHER.
Portrait of Clara and Robert Schumann, c. 1850.
Daguerreotype, 4⅜ x 3¼ in. (10.8 x 8.1 cm).

DAVID OCTAVIUS HILL (1802–1870) and
ROBERT ADAMSON (1821–1848). *The Three Sleepers*
(Sophie Finlay, Annie Farney, and the dog Brownie), c. 1845.
Salt print from paper negative, 7⅝ x 7¼ in. (19.5 x 18.2 cm).

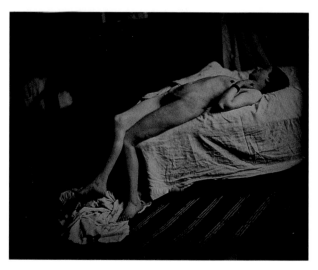

CHARLES NÈGRE (1820–1880).
Nude in the Artist's Studio, 1848. Print from waxed-paper
negative, 4½ x 7⅜ in. (11.3 x 18.7 cm).

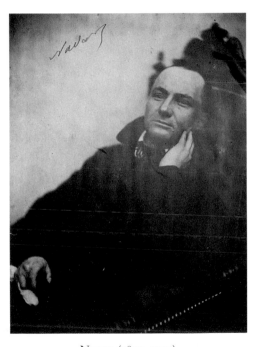

NADAR (1820–1910).
Baudelaire Seated on a Louis XIII Chair, 1855. Unique salt print
from destroyed negative, 8⅜ x 6½ in. (21.2 x 16.4 cm).

CHARLES-VICTOR HUGO (1826–1871).
The Breakwaters at Jersey, plate from a personal album of photographs by Charles-Victor Hugo and Auguste Vacquerie, 1853. Salt print from glass negative, 6⅜ x 7¾ in. (16.1 x 19.8 cm).

GUSTAVE LE GRAY (1820–1884).
Marine (Mediterranean Sea—Mount Agde), 1856–57.
Albumen print from two glass negatives, pasted on
cardboard, 12¾ x 16½ in. (32.6 x 42 cm).

EDOUARD-DENIS BALDUS (1813–1898).
Ruins of the Château de Boves, 1855. Salt print from
paper negative, 13⅜ x 15⅝ in. (34 x 40 cm).

LEWIS CARROLL (CHARLES DODGSON) (1832–1898).
Xie Kitchin Sleeping, 1873. Albumen print from glass
negative, 4⅝ x 5⅝ in. (12 x 14.5 cm).

JULIA MARGARET CAMERON (1815–1879).
Maud, c. 1867. Carbon print from glass negative,
12⅝ x 10⅜ in. (32.3 x 26.5 cm).

PAUL BURTY HAVILAND (1880–1950).
Landscape in the Snow. Carbon print, 2⅝ x 3⅝ in.
(7 x 9.5 cm).

CLARENCE WHITE (1871–1925).
The Kiss, 1904. Platinum print, 9⅝ x 5¾ in.
(24.7 x 14.8 cm).

EUGÈNE ATGET (1857–1927).
Prostitute: Nude in an Interior, 1921(?). Gelatin silver print,
8⅞ x 6⅞ in. (22.5 x 17.5 cm).

INDEX OF DONORS' CREDITS

PAUL CÉZANNE (1839–1906).
Apples and Oranges, c. 1895–1900. Oil on canvas,
29⅛ x 36⅝ in. (74 x 93 cm).

Gift of Charles Hayem (1898), 309

Gift of Dr. Pierre Hébert (1957), 157

Gift of Mme. Roger Jourdain, the model (1921), 80

Gift of Max and Rosy Kaganovitch (1973), 216

Gift of the Fondation Kodak-Pathé, Vincennes (1983), 343

Bequest of M. and Mme. Raymond Koechlin (1931), 129, 130

Gift of Mrs. Phyllis Lambert in memory of her sister Minda Bronfman, baronne de Gunzberg (1986), 344

Gift of Louis Lacroix (1933), 312

Donation Jacques Laroche (1947), 114, 144, 206

Bequest of Jules Lemaître (1914), 32

Bequest of the painter Léon Lhermitte (1926), 63

Gift of Armilde Lheureux (1932), 182

Gift of Frédéric Luce, son of the artist (1948), 162

Bequest of M. and Mme. F. Lung (1961), 175

Gift of Professeur André Lwoff and M. Stéphane Lwoff, sons of the model (1980), 165

Gift of Ernest May (1923), 125

Gift of M. and Mme. André Meyer (1954), 174

Acquired through the participation of Philippe Meyer (1985), 180

Gift of Michel Monet, son of the artist (1927), 122

Gift of Daniel de Monfreid (1927), 317

Acquired with the assistance of Mme. Hubert Morand (1933), 45

Bequest of Etienne Moreau-Nélaton (1927), 93

Gift of Etienne Moreau-Nélaton (1906), 42, 82, 86, 104, 110, 116

Acquired by the Civil List of Napoleon III (1859), 54

Acquired by Napoleon III (1853), 223

Gift of Mme. G. Pasquier, 235

Bequest of Auguste Pellerin (1929), 149

Gift of M. and Mme. Jean-Victor Pellerin (1956), 148

Gift of Joanny Peytel (1914), 139, 210

Gift of Henri Pinard in honor of the comte Robert de Montesquiou (1922), 81

Gift of Paul-Emile Pissarro, son of the artist (1930), 124

Gift of Mme. Pommery (1890), 55

Bequest of Mme. Pontillon (1921), 288

Offered to the state by public subscription through the initiative of Claude Monet (1890), 87

Acquired with the assistance of a public subscription and the Société des Amis du Louvre (1920), 49

Gift of the artist [Puvis de Chavannes], 305

Bequest of John Quinn (1924), 155

Gift of the sons of the artist [Renoir] (1923), 137

Gift of Nicolas and Dmitry Rimskky-Korsakow, sons of the model (1879), 70

Gift of Rodin (1916), 252, 253

Gift of Claude Roger-Marx (1974), 314, 316, 319

Gift of Paul Rosenberg (1912), 53

Gift of Clément Rouart (1992), 307

Gift of Mme. Ginette Signac (1976), 158, 161

Gift of the Société des Amis du Musée d'Orsay, 332; (1989), 266; (1990), 355

Gift of the Société CDF Chimie Téropolynières (1985), 354

Bequest of Mme. Emile Strauss, the model (1927), 33

Gift of M. Roger Thérond (1985), 342

Gift of the comtesse Alphonse de Toulouse-Lautrec, mother of the artist (1902), 186

Gift of A. Vollard (1927), 172

Verbal bequest of Edouard Vuillard, executed through the intervention of M. and Mme. K.-X. Roussel, brother-in-law and sister of the artist (1941), 203

Gift of Pierre Waldeck-Rousseau (1892), 78

Gift of Daniel Wildenstein (1985), 111, 194

Gift of Zagorowsky (1972), 295

Gift of Mme. Emile Zola (1918), 89; (1925), 308

Gift of J. Zoubaloff (1914), 226

INDEX OF ILLUSTRATIONS

362

365

EDITORS: Marike Gauthier and Nancy Grubb
TRANSLATOR: Carol Volk
SERIES DESIGN: Patrick Seymour
PRODUCTION EDITOR: Abigail Asher
PRODUCTION MANAGER: Simone René
All photographs are by Hubert Josse, except for those on pages 271, 320, 323–32, 334, and 341–55, which are from the Réunion des Musées Nationaux, Paris.

Library of Congress Cataloging-in-Publication Data
Treasures of the Musée d'Orsay, Paris / introduction by Françoise Cachin.
 p. cm. — (A tiny folio)
Includes indexes.
ISBN 1-55859-783-2
 1. Art, Modern—19th century—Catalogs. 2. Art, Modern—20th century—Catalogs. 3. Art—France—Paris—Catalogs. 4. Musée d'Orsay—Catalogs.
I. Cachin, Françoise. II. Musée d'Orsay. III. Series: Tiny folios.
N6447.T69 1994
709'.03'407444361—dc20 94-11326